IMAGES
of America

WILLIAMSBURG

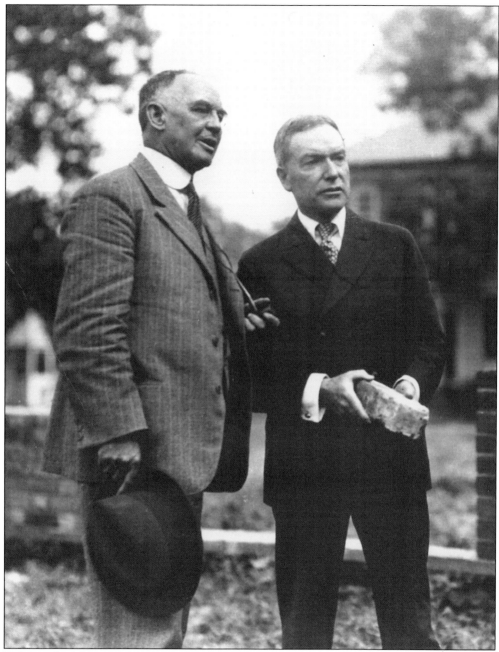

Perhaps the photograph most often reproduced in connection with the restoration of Williamsburg to its 18th-century appearance is this one of the Rev. William Archer Rutherfoord Goodwin, left, rector of Bruton Parish Church, and John D. Rockefeller Jr. And rightly it should be, for no others have had near their impact on 20th-century Williamsburg and its meaning to the nation. It was only through their extraordinary vision and their unbending commitment that Williamsburg was so changed and made a unique living museum to American democracy. (Courtesy of The Colonial Williamsburg Foundation.)

IMAGES
of America

WILLIAMSBURG

Will Molineux

ARCADIA
PUBLISHING

Published by Arcadia Publishing
Charleston, South Carolina

Printed in the United States of America

Library of Congress Catalog Card Number: 2001091532

For all general information contact Arcadia Publishing at:
Telephone 843-853-2070
Fax 843-853-0044
E-mail sales@arcadiapublishing.com
For customer service and orders:
Toll-Free 1-888-313-2665

Visit us on the Internet at www.arcadiapublishing.com

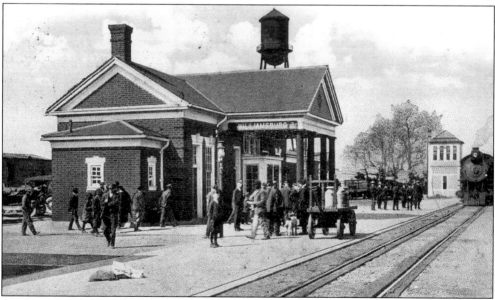

At the start of the 20th century, Williamsburg was a small agricultural community on the railroad that Collis P. Huntington extended in 1881 from the coalfields of western Virginia to the port city he developed, Newport News. Farmers and businessmen in the dusty, old city of 2,000 talked of establishing a cannery as a complement to the knitting mill, a modest industrial enterprise with its own water tower. Of the two state institutions in town, Eastern State Hospital for the mentally ill was larger than the College of William and Mary. There was, while recognized but little developed, the prospect of tourism. This railway station, depicted on a 1920 postcard, was built in 1907 in anticipation of receiving visitors to Jamestown and the colonial capital of Virginia. (Courtesy of C&O Historical Society.)

CONTENTS

ACKNOWLEDGMENTS

There are numerous books about Williamsburg and the restoration of Virginia's colonial capital, but to comprehend the transformation of the city, one needs to turn to Ed Belvin's memoir, *Growing Up in Williamsburg: From the Depression to Pearl Harbor*. Helpful, too, has been *A City Before The State*, Williamsburg's tercentennial history; the 1993 two-volume tercentennial history of the College of William and Mary; numerous publications of The Colonial Williamsburg Foundation; Wilford Kale's two pictorial histories of the college; the newspaper columns and books of Parke Rouse Jr.; Dennis Montgomery's biography of the Rev. W.A.R. Goodwin; out-of-date city directories; and old newspapers. I have also relied on the support and stories of numerous citizens who have rejoiced in living in a place where the remembrance of hometown associations is just as significant as the respect accorded the historic past.

I appreciate the permission of Colonial Williamsburg to reprint photographs from its vast collection. The photographs from the *Daily Press* were rescued, with permission, during a clean-out-the-morgue purge. Unaccredited pictures were taken by unknown photographers or, in some instances, by myself.

With immeasurable appreciation to Mary Sawyer Molineux for her unfailing cheerful help and with her concurrence, this modest effort is dedicated to the members of the Pulaski Club, who are the mirthful and uninhibited guardians of Williamsburg's heritage, both glorious and innocuous.

INTRODUCTION

By the middle of the 17th century, as English settlers claimed homesites along Virginia's tidal rivers, Col. John Page noted the advantages of the high ground near Jamestown, and he and other men of prominence and wealth congregated at Middle Plantation. A church was built and land was staked out for a college, chartered in 1693 by King William III and Queen Mary II.

In 1698, fire destroyed the third statehouse at Jamestown. Gov. Francis Nicholson and the Burgesses met in the college's Main Building and agreed to erect a capitol a mile to the east and to rename the community Williamsburg. Nicholson imposed a geometric pattern of streets with two public greens. He placed the governor's residence overlooking one of them. A Powder Magazine was placed in the center of the other. Nicholson, who could be considered America's first city planner, also specified that dwellings front directly on the broad main avenue, named in honor of Queen Anne's son, the Duke of Gloucester.

Williamsburg received its charter in 1699 and rapidly became the center of English culture in a flourishing agrarian society supported by tobacco. Here clustered the wealthy and the learned, men whose economic well-being was dependent on a far-away sovereign. Williamsburg was a boomtown.

The college evolved an eclectic curriculum offering courses in the classics, religion, medicine, law, and modern languages. It issued George Washington his surveyor's license. Thomas Jefferson studied there; John Marshall attended law lectures.

The city was the capital of an enlightened society. A theater was built, the first in colonial America. A newspaper, *The Virginia Gazette*, circulated widely. In 1773, the Burgesses funded an asylum for "persons of insane and disordered minds." Set back from Francis Street, it was the first public psychiatric hospital in America.

The story of Virginia patriots in Williamsburg—heeding Patrick Henry in the House of Burgesses rile against the Stamp Tax, debating in the Raleigh Tavern the rights of free men, and seeking God's guidance in Bruton Parish Church—is well known. The adoption on May 15, 1776, of the Virginia resolves calling for independence is the noble link that connects Jamestown and the victorious 1781 battle at Yorktown. This is the story that is celebrated by the restoration of 18th-century Williamsburg and the one related by costumed interpreters in the Historic Area.

But once the capital of the commonwealth was transferred to Richmond in 1780, Williamsburg surrendered its importance. Its population dwindled and by 1850 it was only 877. Fire took the

empty Capitol; the college's Main Building and the Raleigh Tavern also burned. Structures across town fell into disrepair and disuse. Patients in the asylum outnumbered students at the college.

At the onset of the Civil War, a bulwark was thrown up just east of Williamsburg; a Confederate fort anchored a row of 12 earthworks. The college president and students enrolled in Virginia regiments. Fierce fighting between elements of armies led by Joseph E. Johnston and George B. McClellan took place on May 5, 1862; the inconclusive Battle of Williamsburg was, until that date, the largest battle ever fought on American soil. Casualties totaled 3,800 with 744 men killed. The Union army occupied Fort Magruder and Williamsburg, and the city was at the edge of no-man's land until Appomattox. Again the college was damaged by fire; homes and personal property were lost. The residents were left in poverty to subsist on pride. The college made an effort to rebuild and reopen, but closed again in 1881—ironically at the same time that the Chesapeake and Ohio Railway ended the city's century-long isolation.

Williamsburg was slow to emerge from the postwar doldrums. The college reopened with state financial aid. By the beginning of the 20th century the city had an ice plant and a knitting mill that manufactured underwear. There were streetlights but no paved roads. The observance in 1907 of Jamestown's 300th anniversary attracted tourists and gave a hint as to the economic possibilities of tourism.

For a few months in 1916 Williamsburg experienced a furious land boom, set off by the construction nearby of a huge DuPont munitions factory. Until the end of World War I thousands of people lived and worked at Penniman, but that town and the plant shut down abruptly after the Armistice.

The college expanded dramatically, enrolling women and building dormitories and classrooms. To solicit private donations, college Pres. J.A.C. Chandler in 1923 hired the Rev. W.A.R. Goodwin to lead the endowment program. The clergyman, who directed the restoration of Bruton Parish Church in 1907, was a master fund-raiser.

Goodwin soon turned his attention toward raising money to save historically significant buildings that were endangered and then, beginning in late 1926, most all of the city, drawing on a silent partnership with John D. Rockefeller Jr. His benevolence was revealed June 12, 1928, when it became necessary to acquire the modern high school that stood on the site of the Governor's Palace.

Much of the city's renovation took place before and during the Great Depression. The Capitol and Raleigh Tavern were reconstructed, inharmonious buildings moved out of the way, and old structures repaired and restored. The work was essentially, but not entirely, completed when the United States entered World War II. Again, Williamsburg was crowded with servicemen. The Navy built Camp Peary nearby as a training base for Seabees. A school for Navy chaplains moved to the W&M campus.

The Jamestown Festival of 1957 was the impetus for considerable commercial development. A second wave of development followed when Anheuser-Busch built in James City County a brewery, a theme park, and a gated residential community. Kingsmill-on-the-James is but the first of several upscale housing projects—most with golf courses—that have made Williamsburg a haven for retirees. While they have altered the age and income demographics, these new residents have enriched the community with financial and volunteer support of local cultural organizations. Williamsburg, a tourist mecca, is in the midst of another golden age.

One

BUILDINGS COME DOWN AND MOVE AROUND

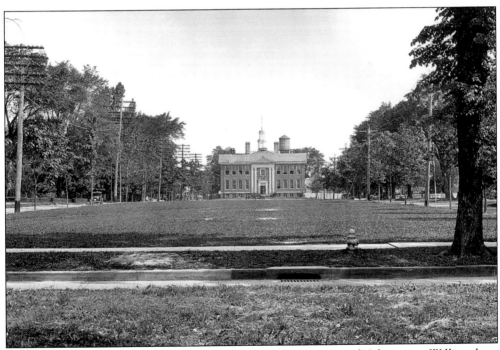

Among the modern buildings that had to give way for the restoration of 18th-century Williamsburg was the Williamsburg High School, built in 1921 and torn down in 1933. The cupola is not that of the school, but that of the colonial Governor's Palace being reconstructed behind it. The water tower was located near the Chesapeake and Ohio Railway tracks and was operated by the Virginia Public Service Company. (Courtesy of The Colonial Williamsburg Foundation.)

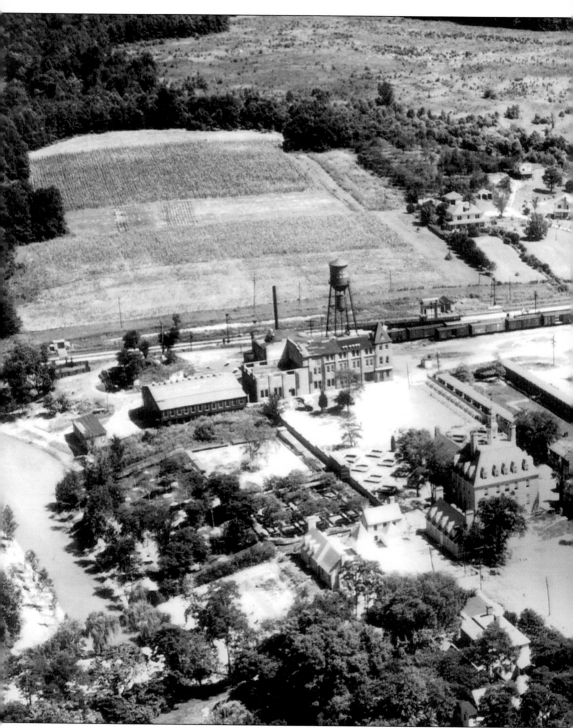

The reconstructed Governor's Palace stands before a patch of dirt where the Williamsburg High School had been in this 1933 photo by the U.S. Army Signal Corps. Utility poles remain along Palace Green. The Virginia Electric and Power Company's plant and water tower were later taken down to make way for the Palace Gardens. Freight cars are parked on the railroad siding

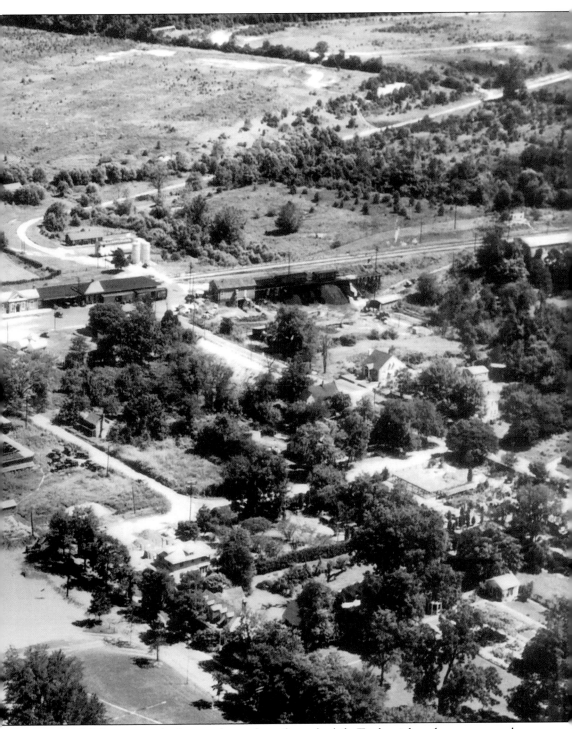

near the C&O station, which was relocated a mile to the left. To the right, what appears to be a dark blot are piles of coal unloaded in a ravine where the Colonial Parkway is now located. (Courtesy of The Colonial Williamsburg Foundation.)

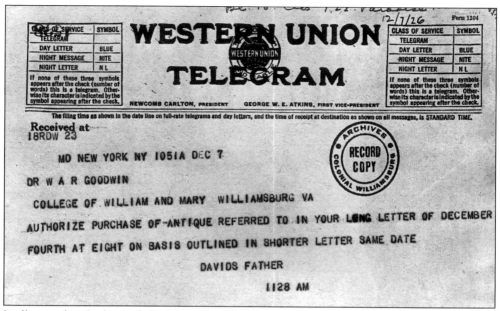

It all started with this coded telegram sent December 7, 1926, by David's Father (i.e., John D. Rockefeller Jr.) to the Rev. W.A.R. Goodwin authorizing the purchase of an "antique" (i.e., the Ludwell-Paradise House on Duke of Gloucester Street). This was the first building acquired for the restoration of Williamsburg. (Courtesy of The Colonial Williamsburg Foundation.)

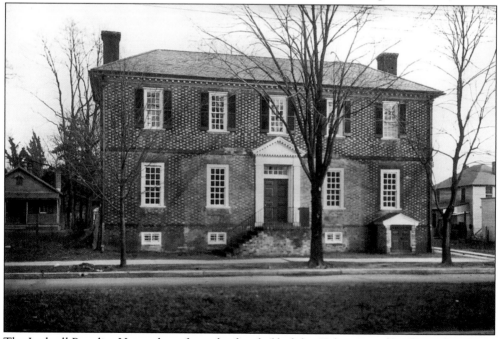

The Ludwell-Paradise House dates from the first half of the 18th century. In the early 1920s a large front porch was removed and an ornamental wooden pediment placed above the front door. This frontispiece was deemed inappropriate and subsequently removed. From 1935 until 1957 the Abby Aldrich Rockefeller Folk Art Collection was housed here. (Courtesy of The Colonial Williamsburg Foundation.)

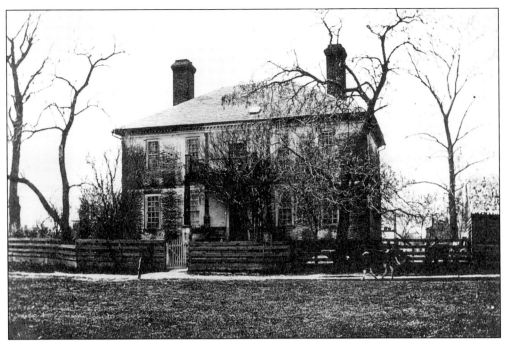

The brick home on Palace Green of George Wythe, a signer of the Declaration of Independence, was George Washington's headquarters before the 1781 Battle of Yorktown. By 1892, when this photograph was taken, it had fallen into disrepair. It was acquired by Bruton Parish Church in 1926, repaired, and served as the office of the Rev. W.A.R. Goodwin when he guided the purchase and restoration of historically significant properties. (Courtesy of The Colonial Williamsburg Foundation.)

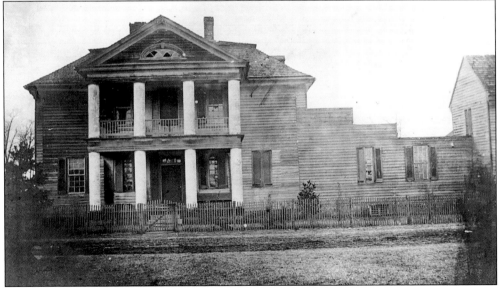

The Robert Carter House, also on Palace Green, dates from 1746 and once served as the residence of Gov. Robert Dinwiddie. In 1932 the inappropriate front porch with its columns and the false front were removed. Although in a dilapidated state, much of its woodwork was intact. (Courtesy of The Colonial Williamsburg Foundation.)

In the mid-1920s, what is now Merchants Square at the western end of Duke of Gloucester Street was a mixture of unpretentious frame homes and business establishments. None of the buildings below Boundary Street, which cuts across the middle of this photo, stands today. Above Boundary Street, the Wren Building on the College of William and Mary campus is almost hidden by

trees. In the Wren Yard, facing each other at opposite points on the triangular walkway, are The Brafferton, left, and the President's House. The modern buildings flanking the Wren are a gymnasium, left, and a science hall, both of which were demolished once the restoration of the Wren Building was completed in 1931. (Courtesy of The Colonial Williamsburg Foundation.)

Utility poles ran down the median strip of Duke of Gloucester Street in 1922 when this picture was taken from the Wren Yard on the William and Mary campus. Two years later a brick wall was built along Jamestown and Richmond Roads to enclose the yard. The spire of Bruton Parish Church is seen to the left of the street. (Courtesy of The Colonial Williamsburg Foundation.)

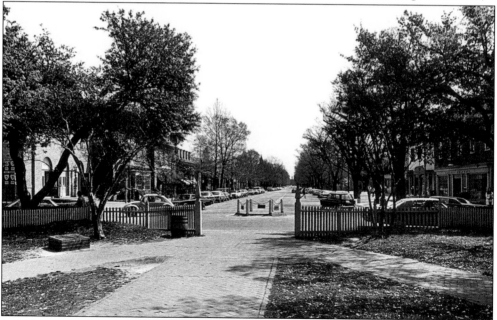

In 1966, automobile traffic was still permitted on Duke of Gloucester Street in Merchants Square. The silhouette of the cupola of the colonial Capitol of Virginia can be seen at the eastern end of Duke of Gloucester Street. The spire of Bruton Parish Church is almost hidden in the trees, but can be picked out above the traffic circle (*Daily Press* photo by Mary Goetz.)

16

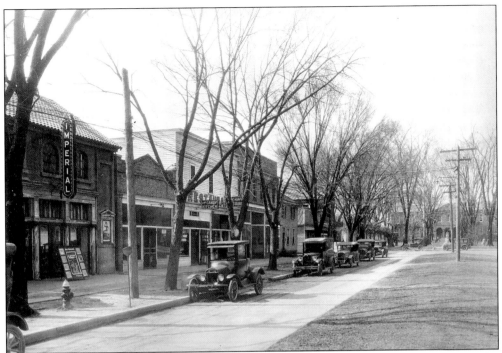

In 1928, the Imperial movie theater and the Candy Kitchen, a popular restaurant, were on the south side of Duke of Gloucester Street at the doorstep of the Wren Building and the William and Mary campus. These and other business establishments were demolished so that Merchants Square could be built in the 1930s. (Courtesy of The Colonial Williamsburg Foundation.)

The curbstones along Duke of Gloucester Street in Merchants Square were ripped up in December 1974 to make way for a pedestrian walkway. The building with the window awnings houses a Howard Johnson's restaurant; today it is Binns Fashion Shop. Behind it and almost hidden is the Williamsburg Methodist Church, torn down in 1981. (*Daily Press* photo.)

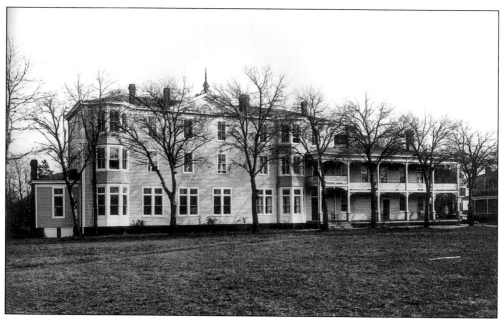

The verandah of the Colonial Hotel looked out on the Courthouse Green and Duke of Gloucester Street, to the right. The hotel was built in 1895 on the site of what is now Chowning's Tavern and it was operated by J.B.C. Spencer, known for his conviviality. At one time, *The Virginia Gazette* published the names of its guests. (Courtesy of The Colonial Williamsburg Foundation.)

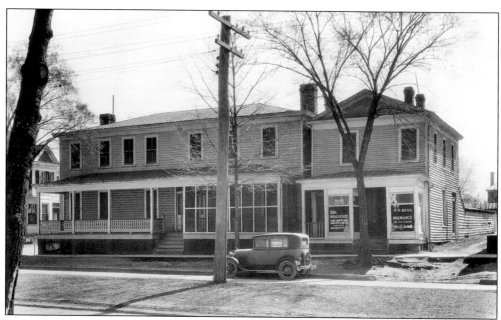

Across the street from the Colonial Hotel was the Market Square Tavern, which dates from the mid-18th century. Originally, the tavern was one-and-a-half stories with dormer windows, but late in the 19th century a full second story and a porch were added. H.W. Dana's real estate office next door handled farms, James River estates, and city lots. (Courtesy of The Colonial Williamsburg Foundation.)

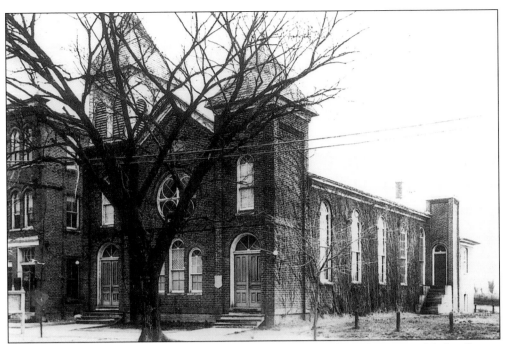

One of the best-known 19th-century buildings that was located on what is now Market Square Green was the Williamsburg Methodist Church, built in 1842 across Duke of Gloucester Street from the Norton-Cole House. The three-story structure next door is the Peninsula Bank Building, built in 1897. (Courtesy of Ed Belvin.)

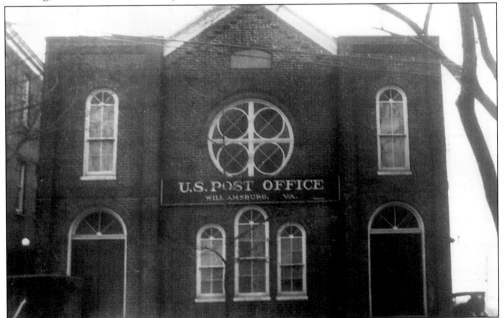

When, in 1926, the Williamsburg Methodists built a new church at Duke of Gloucester and North Boundary streets, this building was sold and used as the city's post office. Subsequently, a new post office was built in Merchants Square with entrances on North Henry Street and, via an arcade, on Duke of Gloucester Street. (Courtesy of Ed Belvin.)

The congregation of the Williamsburg Methodist Church moved into this building at the western end of Duke of Gloucester Street in 1926, about the time this picture was taken. During World War II, citizens manned an aircraft lookout post in the steeple. The congregation moved in 1964 to a new church on Jamestown Road and this building was demolished in 1981. (Courtesy of The Colonial Williamsburg Foundation.)

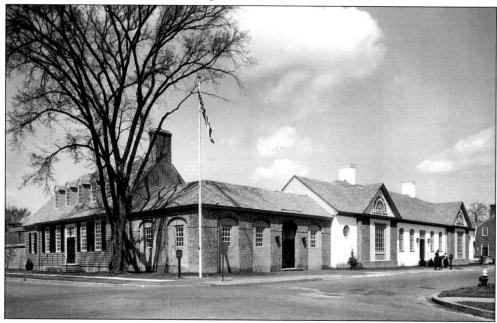

This building at South Henry and Francis Streets was constructed in 1962 to serve as Williamsburg's post office and its exterior was designed to disguise its size. It replaced the post office a block away on North Henry Street. Today this building houses Seasons Cafe and the Henry Street Shops. (Photo by Thomas L. Williams.)

The Peninsula Bank was organized by a group of Williamsburg businessmen and chartered on April 19, 1897—hence the date on this building erected two years later on Duke of Gloucester Street for $2,636. The bank's "burglar-proof" safe was blown open the night of May 25, 1900, and more than $5,000 was taken. Several professional men had offices in this building. The bank moved in 1932 to Merchants Square.

Charles J. Person, a jeweler and chief of the city's volunteer firemen, opened an automobile garage on Duke of Gloucester Street in 1908. In 1910, he established the first Ford dealership in Virginia. His son, William Lunsford Person, later took over the business and in 1931, when this picture was taken, he sold Shell gasoline. (Courtesy of Judge William L. Person Jr.)

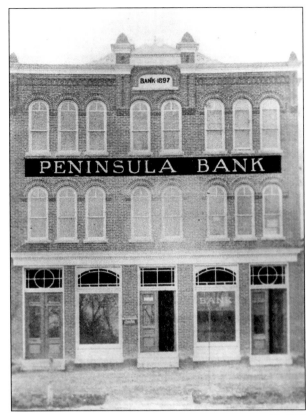

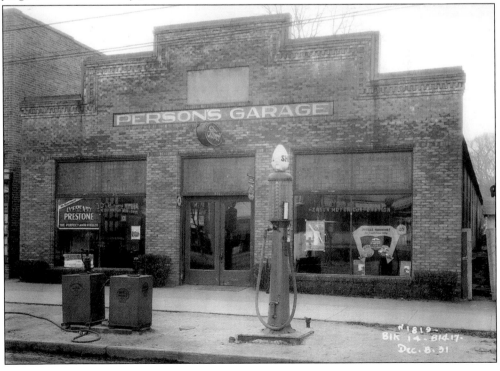

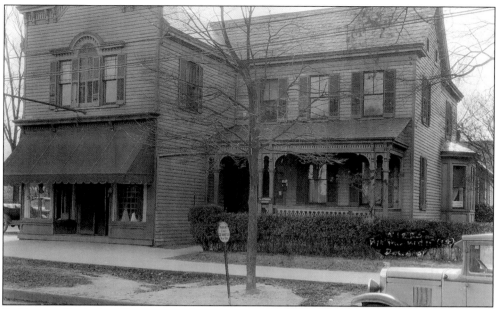

Parking was limited to 30 minutes in busy downtown Williamsburg in 1931. Binns Fashion Shop occupied the store to the left, later moving to the Hitchens Building on North Boundary Street and then to the Stringfellow Building in Merchants Square. H.L. McSheery, masseur, had an office to the right. (Courtesy of The Colonial Williamsburg Foundation.)

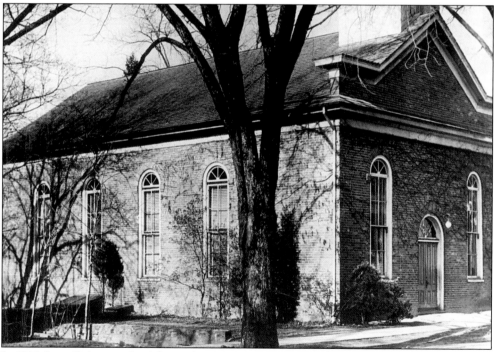

In 1818, Jesse Cole gave the African-American congregation of First Baptist Church, organized in the late 18th century, a lot on Nassau Street. The first church was wooden and was replaced shortly before the Civil War by this brick structure. In 1955 the congregation moved to a new building on Scotland Street. (Courtesy of The Colonial Williamsburg Foundation.)

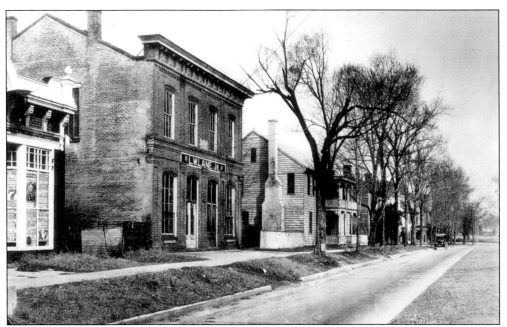

Levin Winder Lane Jr. operated a general store on Duke of Gloucester Street on the site of the 18th-century Raleigh Tavern. Lane was treasurer of the College of William and Mary and served as commissioner of state mental hospitals. His father, Capt. L.W. Lane, established the business after he returned from the Civil War. (Courtesy of The Colonial Williamsburg Foundation.)

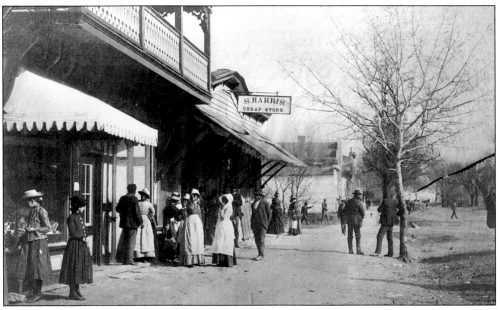

A very remarkable man owned and operated this general merchandise store on Duke of Gloucester Street from 1897 until his death in 1904. Sam Harris was a black entrepreneur and perhaps the richest man in Williamsburg; he lent money to the president of the College of William and Mary and developed property in partnership with a judge. (Courtesy of The Colonial Williamsburg Foundation.)

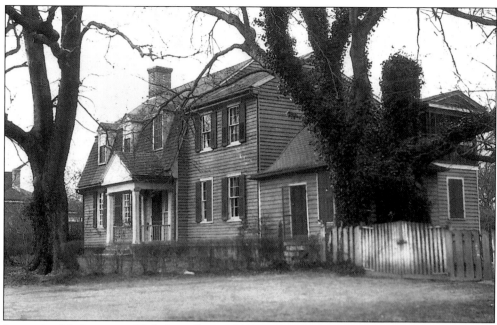

It was in this house on Nicholson Street that on January 4, 1889, the Association for the Preservation of Virginia Antiquities was organized. It was then the home of Cynthia Beverley Tucker Coleman, who did much to preserve the historic landmarks of Williamsburg. Col. John Tayloe owned the gambrel-roofed structure in colonial times; the modern addition has been removed. (Courtesy of Cynthia Barlowe.)

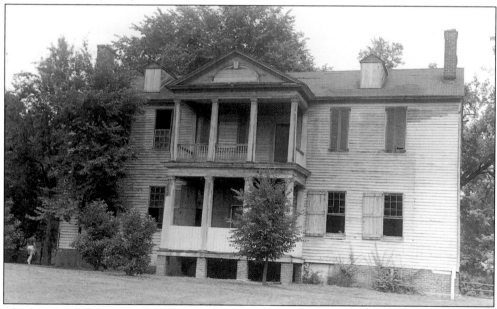

John Randolph, a Tory, built Tazewell Hall, which in the 18th century stood astride what today is South England Street. Early in the 20th century it was occupied by a descendant, Peyton Randolph Nelson, an eccentric who grazed his cows on Palace Green. Tazewell Hall was moved to the west side of the South England Street and then, in the 1950s, dismantled and reassembled in Newport News.

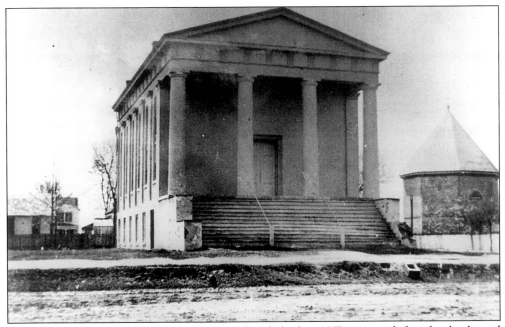

The foundations of the Williamsburg Baptist Church, built in 1857, were made from brick salvaged from a wall that enclosed the colonial Powder Magazine, seen at the right. The congregation moved in 1934 to a new sanctuary on Richmond Road and this building was demolished to open up Market Square Green. (Courtesy of The Colonial Williamsburg Foundation.)

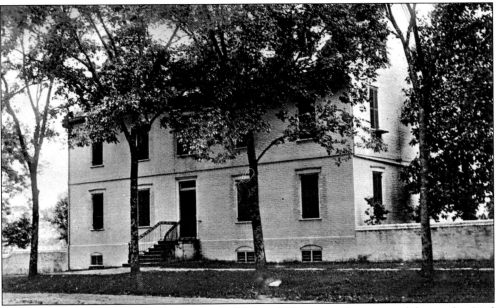

The John Palmer House at the eastern end of Duke of Gloucester Street served during the Civil War as the headquarters of Confederate Gen. Joseph Johnston and then, after the May 5, 1862, Battle of Williamsburg, as the headquarters of Gen. George B. McClellan, commander of the Union forces. The four windows at the left of the front door represent an 1857 addition that has been removed. (Courtesy of The Colonial Williamsburg Foundation.)

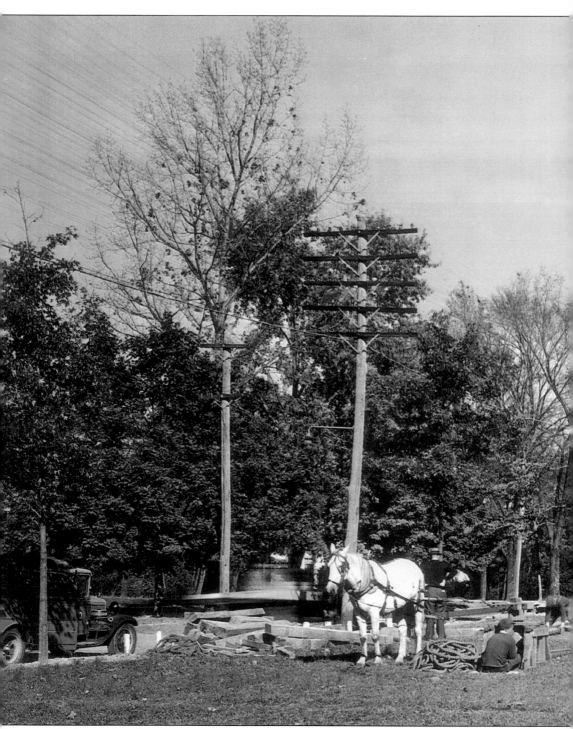

The home of Professor Roscoe C. Young, who taught physics at William and Mary, stood on what was then called Dunmore Street near the reconstructed Governor's Palace. It was prefabricated by Sears and Roebuck and was said to be the first home in Williamsburg to be installed with electric wiring inside the interior walls. To move it, a temporary roadbed of planks was laid

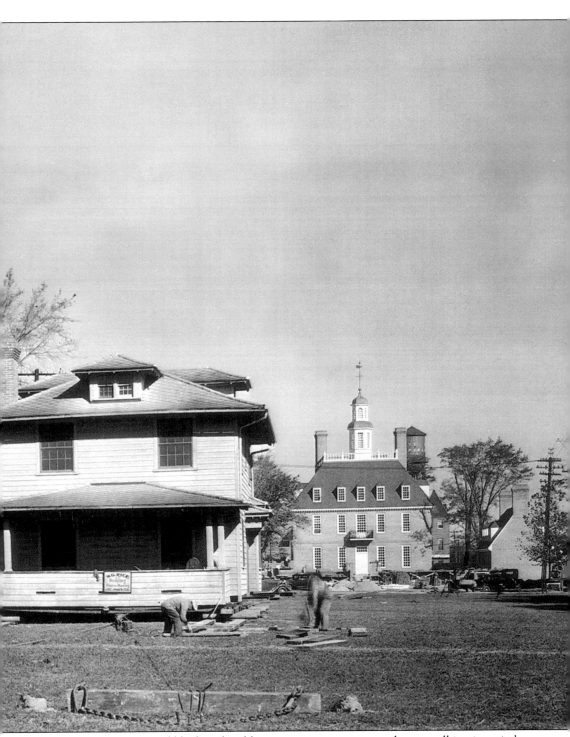

down on Palace Green and block and tackle was strung to permit one horse, walking in a circle around a spindle, to pull it along. The house sat for many years on Scotland Street almost opposite Matthew Whaley School. (Courtesy of The Colonial Williamsburg Foundation.)

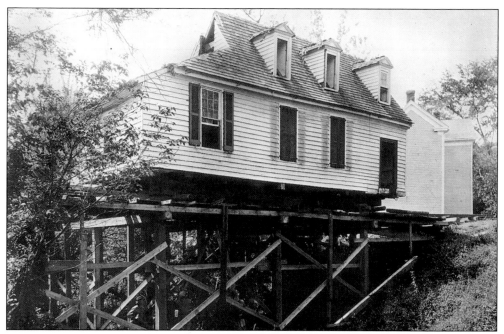

A temporary trestle was built in 1929 to facilitate the move of the Galt cottage across a ravine. Today it stands outside the Historic Area at 420 Tyler Street. Several generations of the Galt family were associated with the administration of Eastern State Hospital. (Courtesy of The Colonial Williamsburg Foundation.)

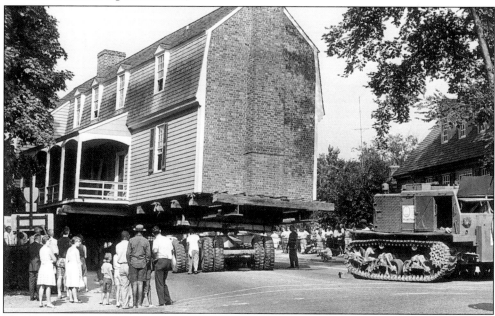

The Travis House, now at Francis and South Henry Streets, has been moved three times. Initially it was placed on Duke of Gloucester Street at the head of Palace Green where it was a restaurant; it was later returned to Francis Street cater-cornered from where it had been. There it was the headquarters for the 1957 Jamestown Festival. In 1968 it was moved back across the intersection to its colonial location. (*Daily Press* photo.)

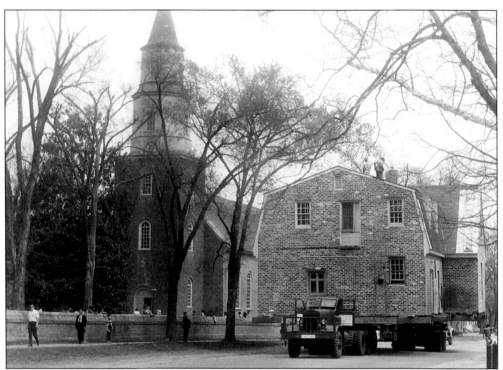

Foster's Gift Shop on East Francis Street was moved down Duke of Gloucester Street in 1968—here passing Bruton Parish Church—and relocated on Jamestown Road at Indian Springs where it serves as the synagogue for the congregation of Temple Beth El. (*Daily Press* photo.)

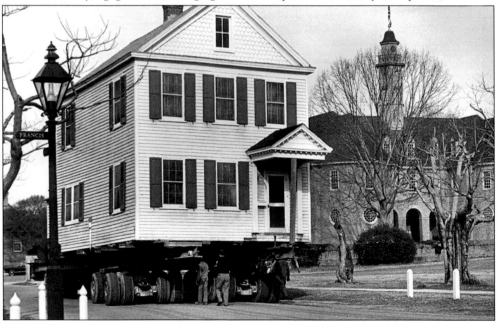

This home, which stood at 504 East Francis Street opposite the colonial Capitol, was owned by Jeanette Morris and acquired by Colonial Williamsburg in 1967. It was moved in 1969 to 510 Tyler Street, and torn down in 1985. (*Daily Press* photo.)

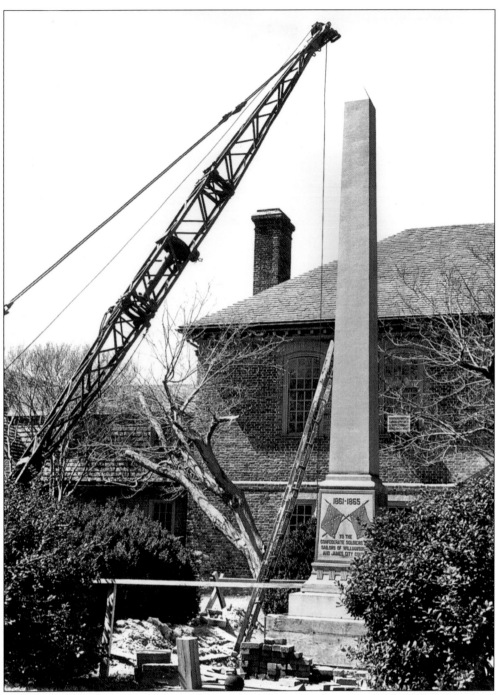

Perhaps no Confederate monument in Virginia has been moved more times than the one erected on Palace Green on May 5, 1908, the 46th anniversary of the Battle of Williamsburg. It was removed in 1931 and for a while lay on the ground in Cedar Grove Cemetery before it was put up in front of the courthouse on South England Street. In 1969 it was taken down, as seen here, and moved to the courthouse on Court Street where it stayed until 2000. When that courthouse was abandoned, the stone obelisk was moved across the street to Bicentennial Park.

The one-block segment of South England Street between Duke of Gloucester and Francis Streets was ripped up in January 1966 in order to restore the open space of Market Square Green. Before the restoration of Williamsburg, this street had been the center of "downtown" Williamsburg. (*Daily Press* photo.)

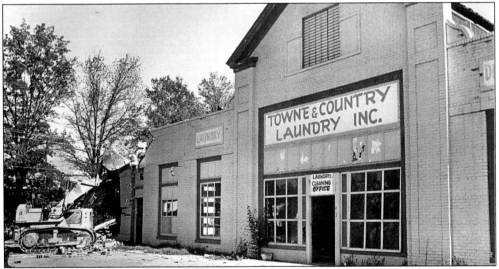

Redevelopment has taken place outside the Historic Area. The Towne & Country Laundry on North Boundary Street, a business established in 1922, was demolished to make way for a building used by the Chesapeake and Potomac Telephone Company and later as the library for Colonial Williamsburg. It was demolished as part of the city's redevelopment of the Northington Block. The Williamsburg Area Chamber of Commerce building now stands in the area where the laundry did. (*Daily Press* photo.)

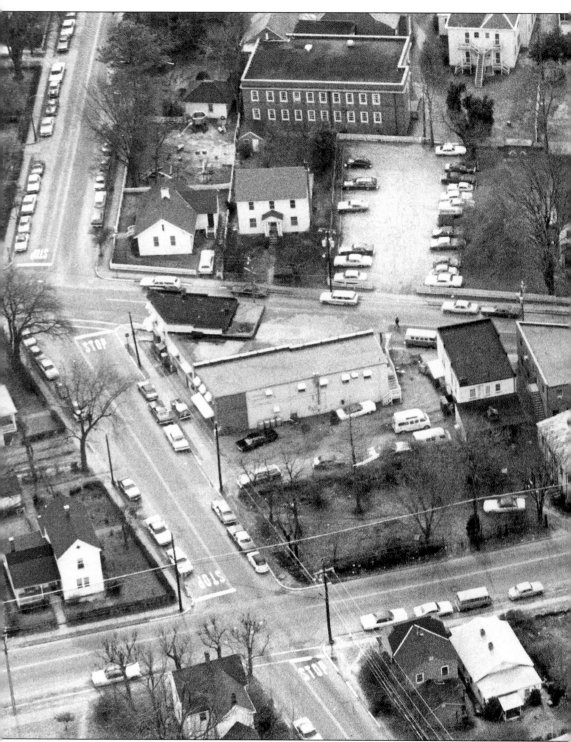

All the buildings in the Triangle Block have been demolished and a restaurant and shops now front Armistead Avenue, to the left. The two-story brick building with a triangular-shaped roof was the clinic of Dr. J. Blaine Blayton. The housing development that now stands on Scotland

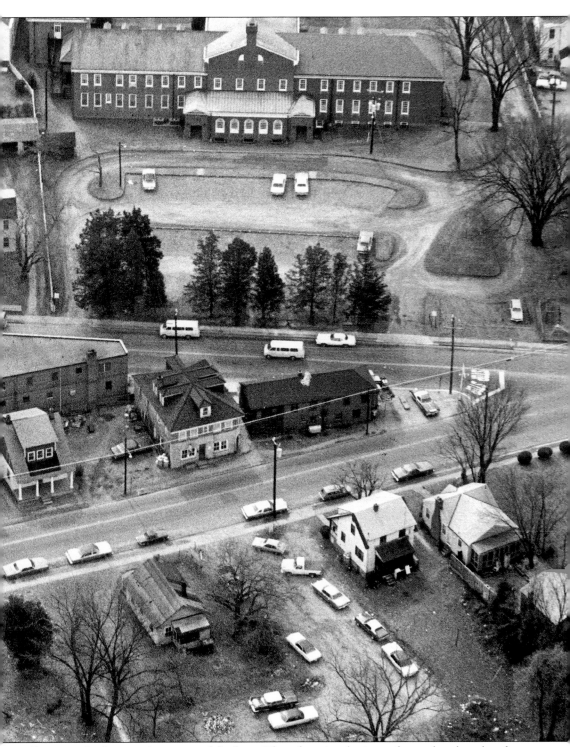

Street at the lower right is named for him. The educational wings of two churches that face Richmond Road are at the top of the picture—the Presbyterians to the left and the Baptists to the right. (*Daily Press* photo by Jim Livengood.)

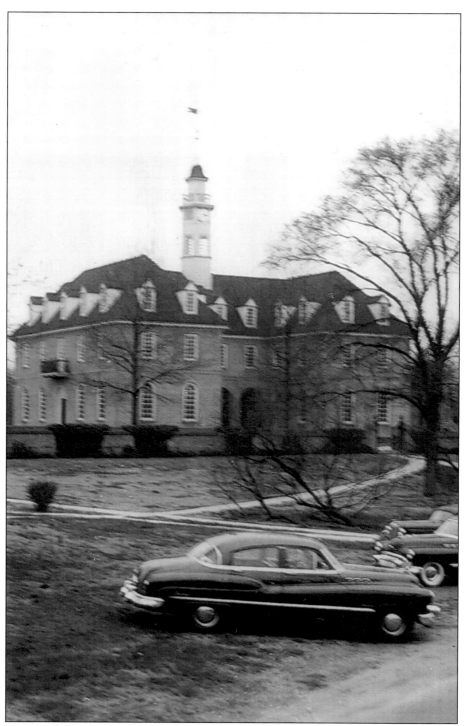

Once automobiles were prohibited from the Historic Area in 1963, after a series of trials with street closure, the restoration took on the atmosphere of an 18th-century community rather than being a collection of buildings restored to their colonial appearance. This photograph of cars parked inharmoniously before the Capitol was taken in 1948.

Two

Two Institutions
W&M and ESH

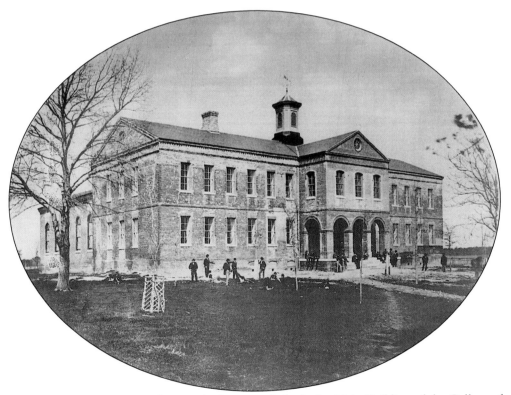

It has been said that the college made the town. Indeed, the Main Building of the College of William and Mary was in place before the city was chartered in 1699. During the Civil War, soldiers from Pennsylvania, without authorization, set fire to the oldest academic building in America and turned the ruins into a fortified position. In 1869 it was rebuilt. This building was restored to its 18th-century appearance by John D. Rockefeller Jr. in 1931, and named for its likely architect, Sir Christopher Wren. (Courtesy of College of William and Mary Archives.)

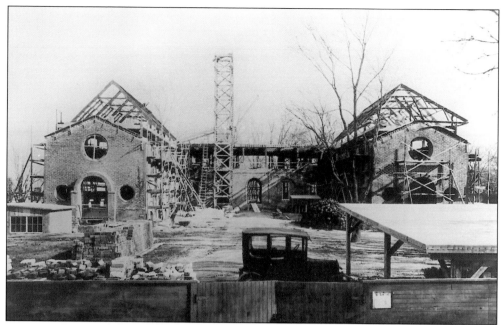

Reconstruction of the Wren Building was begun in 1929 and the auspicious discovery of a long-forgotten copper engraving plate in a British museum enabled the builders to incorporate the unusual design of the rear dormer windows. The chapel is situated in the wing to the right. The Great Hall, in the wing at the left, had been diminished by lowering the ceiling to accommodate a second story. (Courtesy of The Colonial Williamsburg Foundation.)

The "College Hotel" on Jamestown Road was purchased in 1859 to house boys who had been displaced by the fire that had gutted the Wren Building that year. The dormitory was renamed Ewell Hall in 1894 upon the death of college Pres. Benjamin S. Ewell. It was demolished in 1927. (Courtesy of College of William and Mary Archives.)

Taliaferro Hall was built next to the College Hotel in 1894, in part with money appropriated by Congress in partial compensation for the college's losses during the Civil War. It was a dormitory until it was renovated in 1937 to house the department of fine arts. Taliaferro Hall was demolished in 1963. (Courtesy of College of William and Mary Archives.)

This gymnasium was constructed to the southwest side of the Wren Building in 1901 and was converted to classroom use in 1922. It then housed the Marshall-Wythe School of Government and Citizenship, headed by John Garland Pollard, who in 1930 was elected governor of Virginia. Citizenship Hall was demolished in 1931.

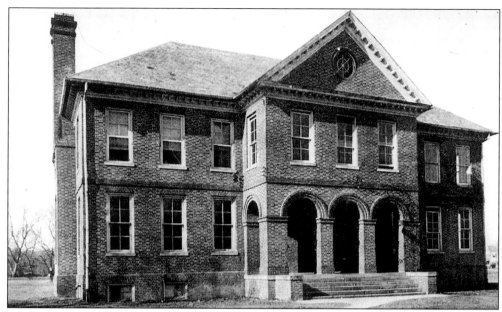

This classroom building was constructed to the northwest side of the Wren Building in 1906 and housed the science department. A greenhouse was located nearby. When Ewell dormitory was demolished in 1927, this building was named Ewell Hall. It was demolished in 1932. (Courtesy of College of William and Mary Archives.)

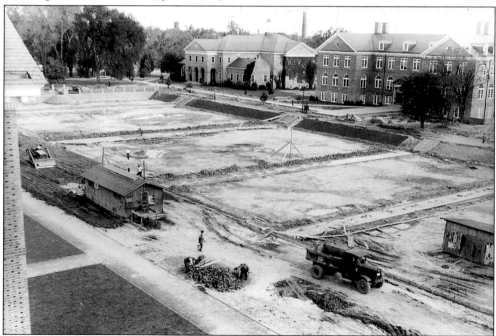

A focal point of the campus built behind the Wren Building is a Sunken Garden, inspired by the grounds associated with buildings in England designed by Sir Christopher Wren. This picture of its construction was taken in the summer of 1935 from what was then Marshall-Wythe Hall. The buildings opposite are, at the left, Phi Beta Kappa Hall, and to the right, Washington Hall, an academic building. (Courtesy of College of William and Mary Archives.)

The focal point of the new extended campus built in the 1960s during the administration of Davis Y. Paschall is a replica of a sundial that stood in front of the President's House from 1815 until the Civil War. It was returned to the College Yard in 1912 by the staff of the campus newspaper, *The Flat Hat*, in celebration of its first year of publication, and is now housed in Swem Library. The replica was placed in 1971 at the confluence of walkways. (*Daily Press* photo.)

One of the principal buildings erected during the Paschall era was the 10,000-seat William and Mary Hall, built on the old Civilian Conservation Corps field. It houses the physical education department and serves as the college's basketball arena and convocation hall. The first basketball game was played in December 1970 before the building was completed; the University of North Carolina won, 101-72. (*Daily Press* photo.)

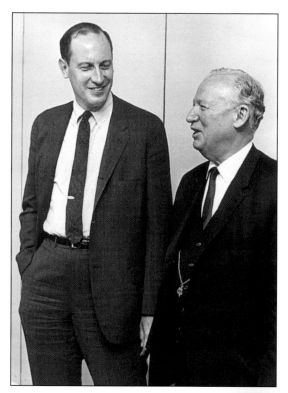

Davis Y. Paschall (right), an alumnus of William and Mary, served as the college's 23rd president from 1960 until 1971. Thomas A. Graves Jr. (left), associate dean of the School of Business Administration at Harvard University, succeeded him. Graves continued Paschall's program of building new academic halls and dormitories and he introduced a revival on campus of encouraging the fine arts. Graves retired in 1985. (*Daily Press* photo.)

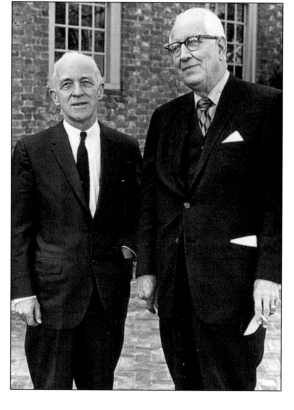

Carter O. Lowance (left), succeeded W. Melville Jones (right), as the college's vice president in 1970 after serving as chief administrative assistant to six Virginia governors. Jones, who joined the faculty as a member of the English department, served as dean of the faculty and dean of the college before becoming vice president in 1968. (*Daily Press* photo.)

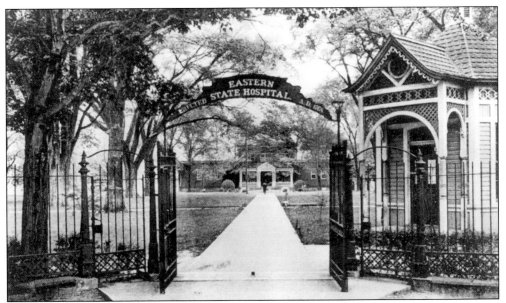

It used to be said, with a painful degree of accuracy, that Williamsburg was a place where "500 lazy live off 500 crazy"—a reference to Eastern State Hospital. Indeed, the Lunatic Asylum that was founded in 1773 was, before the revival of William and Mary after World War I, the major institution in the city. The hospital's front gate was on Francis Street. (Courtesy of Library of Virginia.)

Cameron Hall on Francis Street was an auditorium that, before 1913, was used regularly as a dance hall by townspeople and students. In it, school commencements were held, politicians on the stump gave speeches, and silent movies were shown. The building, last used to house the Colonial Williamsburg Fife and Drum Corps, was demolished in 1969.

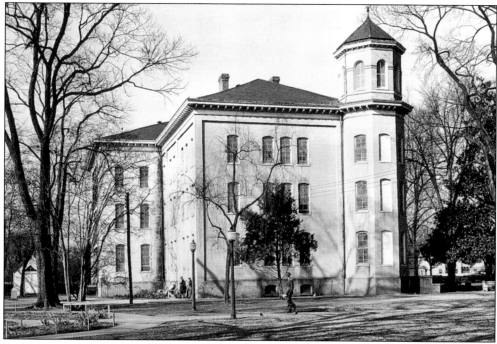

Built in 1881, the John R. Thurman Building housed 275 male patients at Eastern State Hospital when the hospital grounds were in downtown Williamsburg. This picture was taken in 1962 when the Thurman Building was abandoned and its patients transferred to new facilities at Dunbar Farm west of the city. It was named for a 19th-century hospital administrator.

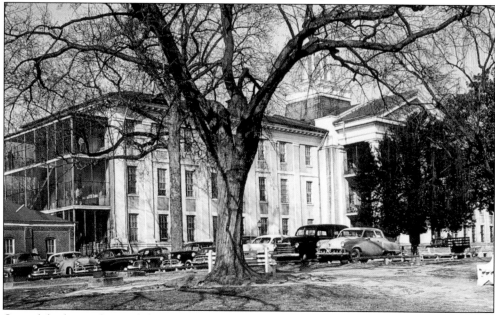

One of the largest hospital dormitories was Montague Hall for men, the rear of which flanked closely on South Henry Street. The small brick building to the left was a dining room. Patients were restricted to the hospital grounds. The hall was named for Andrew Jackson Montague, who was governor from 1902 to 1906.

The Taylor Building, erected in 1892, housed female patients. Once all the Eastern State patients were transferred to the Dunbar Farm site, ownership of the downtown property was transferred to the College of William and Mary and then sold to Colonial Williamsburg, which then reconstructed the mental hospital of 1773. (Photo by George Von Dubell.)

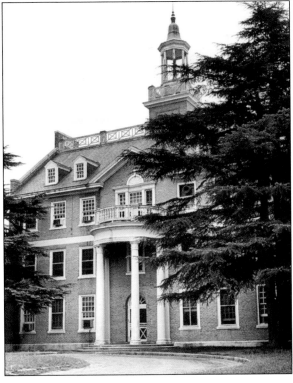

The Brown Building, which faced South Henry Street, was built in 1925 as the diagnostic building for Eastern State patients. It was named for Dr. George Woodford Brown, who served as the hospital's superintendent from 1911 until 1943. The building was abandoned in 1969 and demolished in 1974. The National Center for State Courts broke ground on this site in 1976. (*Daily Press* photo by Mary Goetz.)

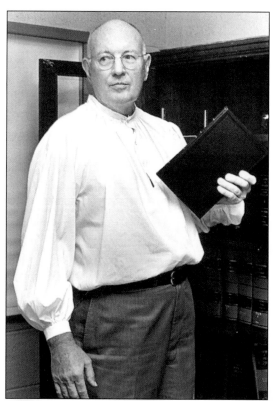

Dr. Howard H. Ashbury, seen here modeling a colonial-style shirt, served as superintendent of Eastern State Hospital from 1960 until 1972. He oversaw much of the hospital's move to the Dunbar Farm site. (*Daily Press* photo.)

Dr. Kurt T. Schmidt (below right), was superintendent from 1972 until 1979. With him are Dr. Hugh Stokes, who was a general practitioner in Williamsburg before he took psychiatric training and joined the hospital staff, and Ruth Skillman, an administrative nurse. (*Daily Press* photo.)

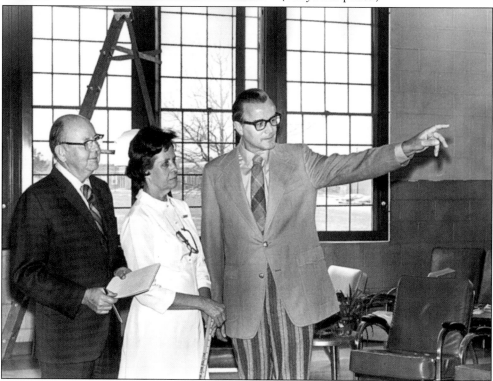

Three

SERVING THE CITIZENRY

Williamsburg's City Hall in 1928 was this unpretentious wooden building with a shaky balcony. It stood on a section of South England Street between Duke of Gloucester and Francis Streets which no longer exists. The Courthouse of 1770, facing Duke of Gloucester Street, is the brick building to the right. Note the small oil can left at the curbside between the two trees. (Courtesy of The Colonial Williamsburg Foundation.)

Wash tubs are hung on pegs outside a rear second-story window of Williamsburg's City Hall in 1928. The building faced the octagonal-shaped Powder Magazine, which then was often called the Powder Horn. The cupola, seen partially at the right of City Hall, is that of the fire station. (Courtesy of The Colonial Williamsburg Foundation.)

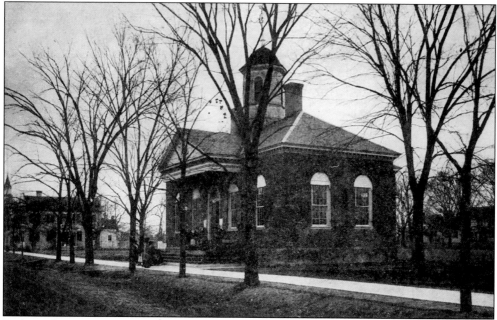

Early in the 20th century, the Williamsburg City Council met in the Courthouse of 1770 on Duke of Gloucester Street, then commonly referred to as Main Street. J.H. Stone published this postcard sometime before 1911, the year in which the courthouse was gutted by fire. When it was rebuilt, four columns were added to the portico.

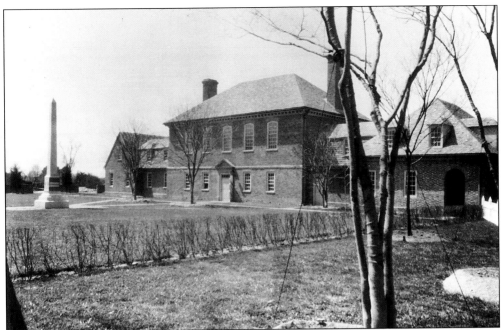

This handsome building served as the courthouse for Williamsburg and James City County from 1932 until 1967. It was located on South England Street and was built when Colonial Williamsburg acquired the Courthouse of 1770. This site is now a parking lot for the Williamsburg Lodge. (Courtesy of The Colonial Williamsburg Foundation.)

Two of Williamsburg's municipal buildings are shown in this undated photograph made when brick sidewalks were laid down North Boundary Street. For many years the city manager's office was in the small building to the left. The police department was housed in the rear with an entrance on Henley Street. This building was demolished in 1985. The Municipal Hall to the right, now called the Stryker Building in memory of long-time Mayor H.M. Stryker, was built in 1967. (*Daily Press* photo.)

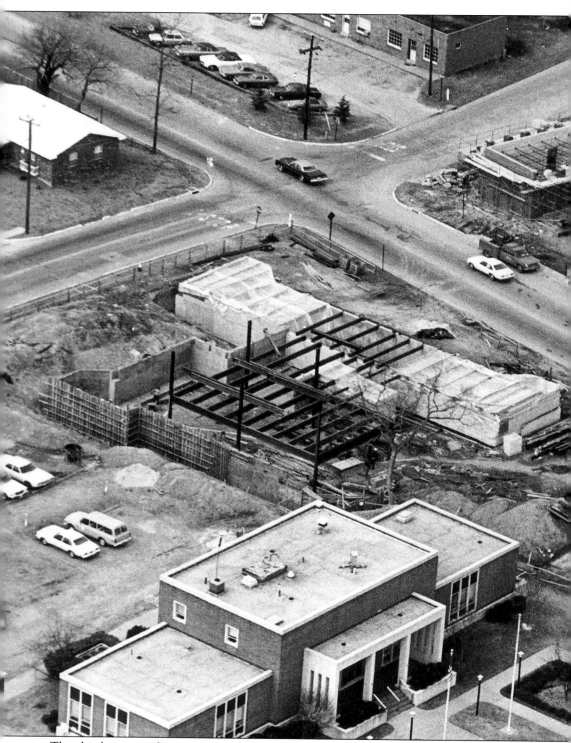

The development of a municipal center got underway in 1977 when the city constructed buildings to house the police department, immediately above the Municipal Building in the lower left, and the fire department on Lafayette Street. The one-story commercial building

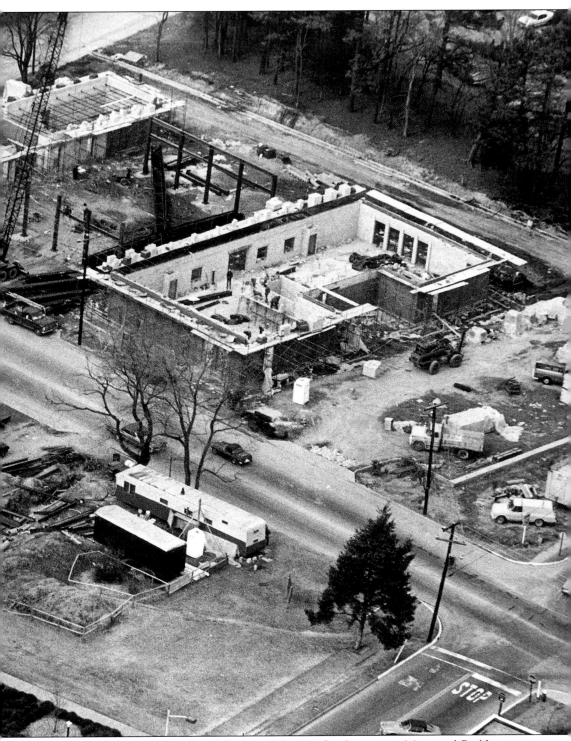

at the top of the picture was demolished to make way for the present Municipal Building on Lafayette Street. (*Daily Press* photo by Jim Livengood.)

Construction of the first permanent building for the Williamsburg Regional Library began on Scotland Street in 1972. The architect was Wright B. Houghland, who later was elected to the City Council. For 40 years before moving in, the library had been housed in the Nicholas-Tyler Office at Francis and South England streets. (*Daily Press* photo.)

Construction of the shelter for Waller Mill Park began in the spring of 1972. Initial plans for the park, drawn by Stanley W. Abbott and his son, Carlton, included a golf course and an ice-skating rink, neither of which have been built. The hiking trails, picnicking areas, and canoes are well used. (*Daily Press* photo.)

Frank Force (seated), succeeded Hugh Rice as Williamsburg's city manager in 1967. Rice began his service in 1948 and after stepping down he spent two years setting up a department of finance for the city. Force retired in 1991, and was succeeded by Jackson C. Tuttle II. (*Daily Press* photo.)

Members of the City Council during the 1950s pose with the clerk of council, Anne D. Jones (left), and the city manager, Hugh Rice (seated right). Standing from left to right are G. Winston Butts, who owned a furniture store; Yelverton O. Kent, manager of the William and Mary bookstore; and Vincent D. McManus, a surveyor. Seated from left to right are Lloyd Haynes Williams, a journalist with the *Daily Press* of Newport News, and Dr. Henry Morris Stryker, a dentist. (Photo by George Von Dubell.)

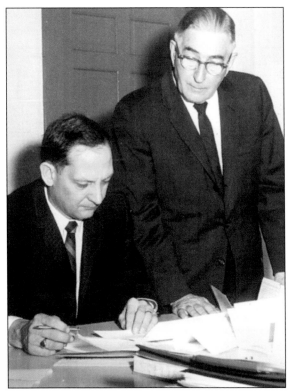

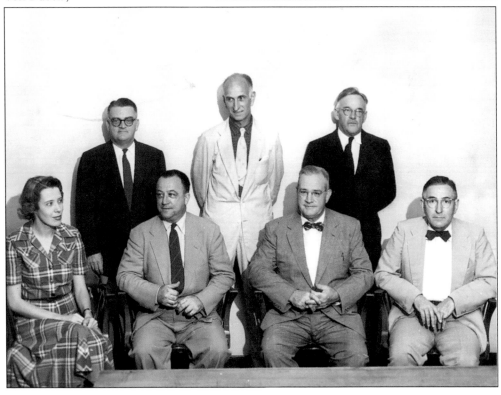

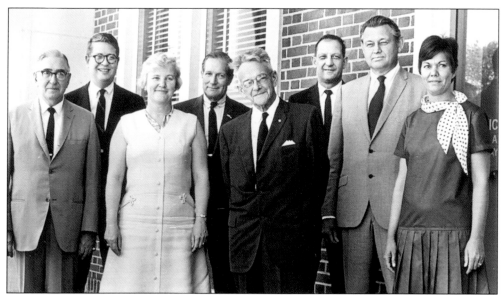

Members of the City Council pose in 1967 with retiring City Manager Hugh Rice (left), incoming City Manager Frank Force (third from the right standing in the back row), and Lois Bodie, clerk for council. Council members are, from left to right, Vernon M. Geddy Jr., an attorney; Stella Neiman, a civic activist; Charles Hackett, a Colonial Williamsburg vice president; Vincent D. McManus, a surveyor, and Robert S. Hornsby, businessman and developer.

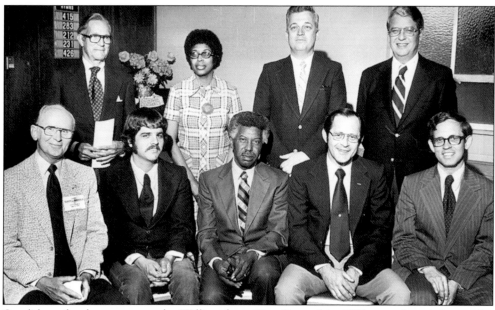

Candidates for three seats on the Williamsburg City Council in 1976 were, from left to right, (seated) Elmer Blekfeld, Leroy Hubert, Phil Cooke Jr., Donald Pons, and James N. McCord; (standing) Vice Mayor Charles W. Hackett, Esterine Moyler, Gilbert L. Granger, and Mayor Vernon M. Geddy Jr. Councilman Robert S. Hornsby did not seek re-election. Geddy was re-elected and newcomers McCord and Granger were elected, retiring Hackett. (*Daily Press* photo.)

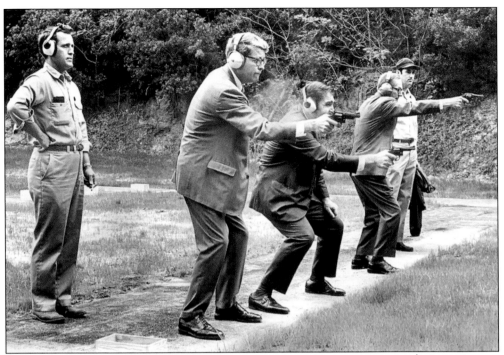

City Police Chief Andy Rutherford, center on the firing line, took two council members to the pistol range which, before South Henry Street was extended to Route 199, was located at College Landing, now a city park. Firing at the left is Mayor Vernon M. Geddy Jr. and at the right, Charles Hackett. The instructors are unidentified. (*Daily Press* photo.)

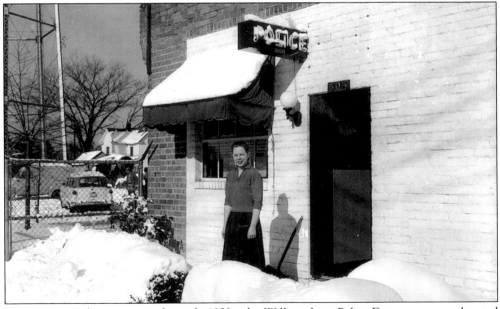

For many years beginning in the early 1950s, the Williamsburg Police Department was located on Henley Street at the rear of the city manager's office. The city garage and water tower were behind the building. Three of Captain Llew Smith's children—Bea, shown here, Llew Jr., and Ed—served at various times as police dispatchers. (Courtesy of Janet and Llew Smith.)

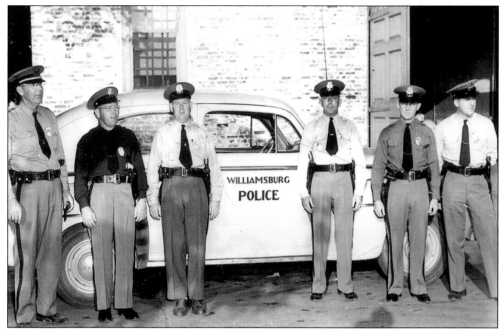

Members of the Williamsburg Police Department in the mid-1940s were, from left to right, Chief William H. Kelly, Hamlet Smith, Llew Smith, Hardy Rabun, Steve Stevens, and Bob Berry. One of these men usually could be found at College Corner. (Courtesy of Janet and Llew Smith.)

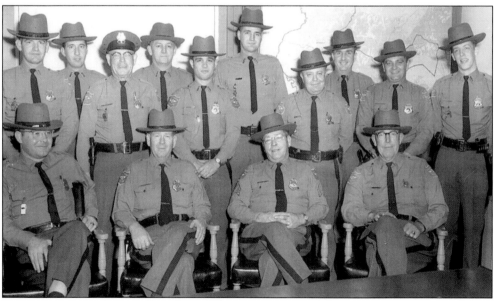

In 1965, members of the Williamsburg Police Department lined up for this photo. Seated from left to right are Andy Rutherford, who later served as chief, Captain Llew Smith, Captain Hamlet Smith, and Chief William H. Kelly. Standing from left to right are Dan Gardner, Russell Hayes, J.T. Glass, Tom Fisher, Darrell Warren, Mike Lashly, Jesse Altizer, Cliff Montgomery, Doug Ratcliffe, and Walter Robertson. Glass wears a different hat because he was the parking control officer. (Courtesy of Janet and Llew Smith.)

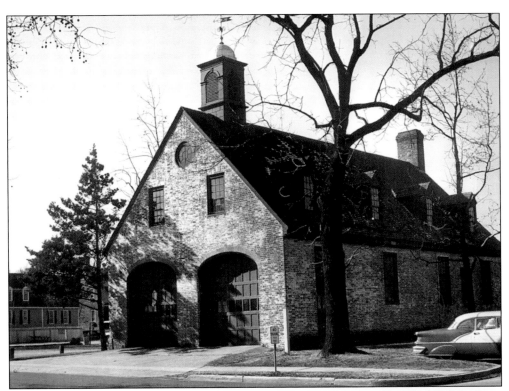

Fire protection was greatly improved once the restoration of Williamsburg began. This firehouse on South Henry Street was built in 1928 and for many years also served as the home station for the police department. It was torn down in 1961 to make way for the construction of a post office. (*Daily Press* photo.)

After a tragic fire in Market Square Tavern in which a tourist died, city officials brought Elliott W. Jayne from Long Island to serve as the city's fire marshal. He received national attention for the innovations he brought to the department, including the radio dispatch of volunteers and the building of a fire training school. Here he is being honored, along with his wife, Anne, for his years of service from 1950 to 1962. (Photo by Thomas L. Williams.)

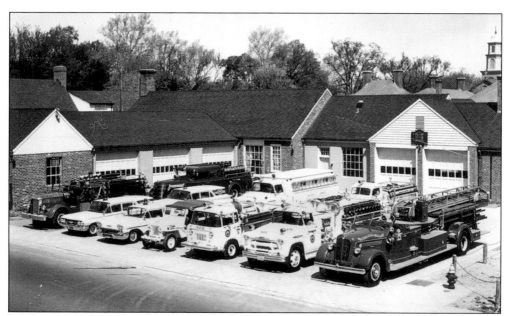

From 1961 until 1978 the Williamsburg Fire Department was housed on Francis Street in a building which previously housed the Person auto garage and Ford dealership. At that time, city firemen routinely responded to fire and rescue calls in James City and York counties. The Jeep at the center of the front row was used effectively to fight brush fires. The ambulances to the left of the Jeep were converted station wagons. The cupola in the distance is that of the Williamsburg Methodist Church.

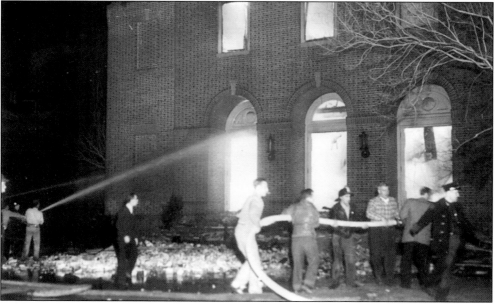

Volunteer firemen under the leadership of Fire Marshal Elliott W. Jayne combat the December 27, 1953, inferno that destroyed Phi Beta Kappa Memorial Hall on the William and Mary campus. Miraculously, they saved the priceless colonial records of the national academic society. A new auditorium was built in 1957 on Jamestown Road and this structure was rebuilt to house the college's music department. (Photo by Fred L. Frechette.)

Damage was estimated at more than $500,000 when flames broke through the roof of the Drug Fair store on Monticello Avenue the night of January 19, 1971. The store was a total loss and three adjoining businesses, including a grocery store, were damaged. It was the most costly fire in the city since the burning of Phi Beta Kappa Hall. (*Daily Press* photo.)

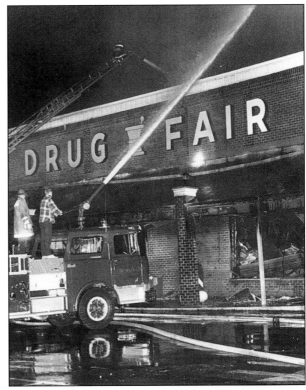

From August 1965 until September 1981, Val J. Wasson represented the interests of the business community as executive director of the Williamsburg Area Chamber of Commerce. Here he enters Marshall Lodge, off Francis Street, which during a great part of his tenure served as the chamber's office. (*Daily Press* photo.)

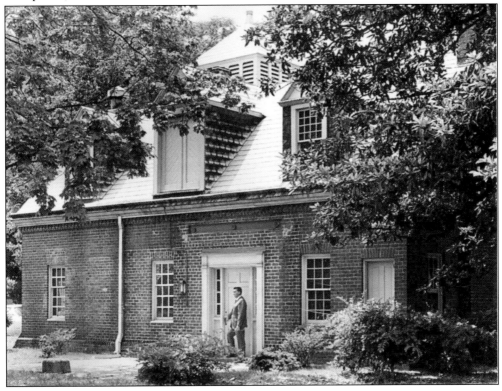

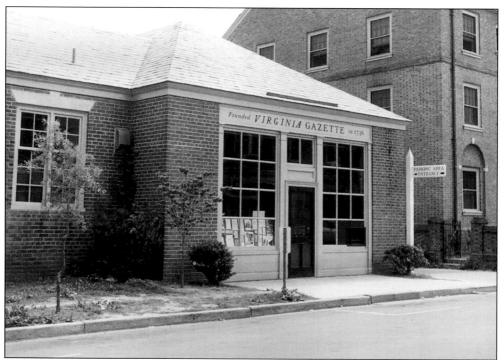

The fourth estate has been represented in Williamsburg since 1736—with some breaks in the continuity—by *The Virginia Gazette*, which in 1972 was located at 420 Prince George Street. The newspaper was revived in 1930 by J.A. Osborne of Salem and published by members of his family until 1960. It was then run by John O.W. Graveley III and subsequently by his wife, Martha, for 26 years. This building now houses the Cheese Shop.

William C. Johnston, who previously owned and edited *The Virginia Gazette*, opened the Williamsburg Bureau of the Newport News *Daily Press* in 1922. The bureau occupied the first floor of this office building at 310 North Boundary Street from November 1969 until November 1977, when it moved to 104 Bypass Road. This building and the house next door were demolished to make way for the expansion of the Williamsburg Regional Library and the development of the municipal center.

Four

ACCOMMODATING VISITORS

To accommodate the influx of visitors for the Jamestown Festival of 1957, Colonial Williamsburg built a $1.5 million information center with twin theaters in which to show its new orientation film, *Williamsburg: The Story of a Patriot*. The Motor House was built at the same time. Gov. Thomas B. Stanley spoke at the dedication of the complex, which has recently undergone extensive renovations.

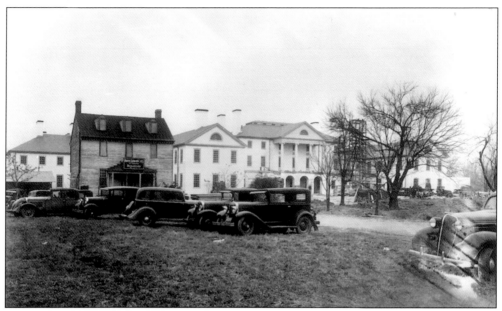

The contractor, John Lowery Inc. of New York, used an abandoned home as his headquarters for the construction of the Williamsburg Inn in 1937. John D. Rockefeller Jr. and his wife, Abby, were intimately involved in the design and furnishing of this Regency-style hotel that for many years received the Mobil Travel Guide's Five-Star Award. It recently underwent a complete renovation. The Golden Horseshoe Golf Course was built immediately following World War II. (Courtesy of The Colonial Williamsburg Foundation.)

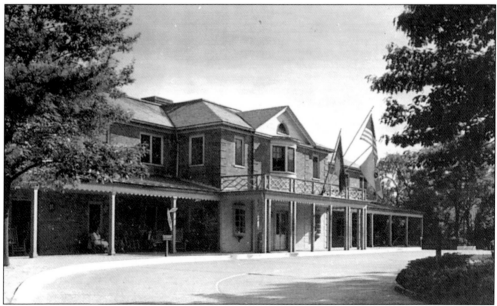

The Williamsburg Lodge was built in 1937 by Colonial Williamsburg as a less elegant companion to the Williamsburg Inn. The original entranceway was changed in 1963 when a conference center was added to the front of the hotel. At the same time a 56-room wing was added; years later another wing was built, along with a fitness center. Walter H. Miller made this postcard photograph.

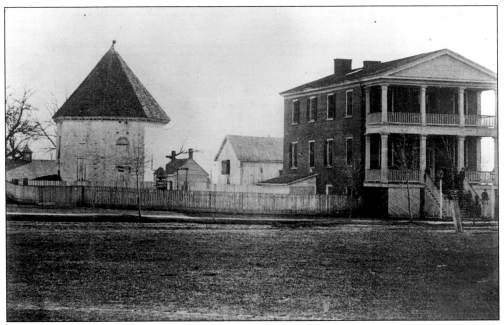

It is believed that the Williamsburg Hotel, which stood on Duke of Gloucester Street next to the Powder Magazine, was built in 1854. During the Civil War it was used as a hospital and, in 1911, when the courthouse burned, the circuit judge held court in it. In 1926 it was purchased by Dr. Baxter I. Bell Sr. and used as a hospital. (Courtesy of The Colonial Williamsburg Foundation.)

The family of Alexander and Helen Vena Sacalis operated one of the early tourist homes in Williamsburg. They called it the John Rolfe House and it was located within easy walking distance of the Historic Area at 438 Scotland Street. It has since been torn down. (Photo by Douglas B. Green II; courtesy of Elizabeth Sacalis.)

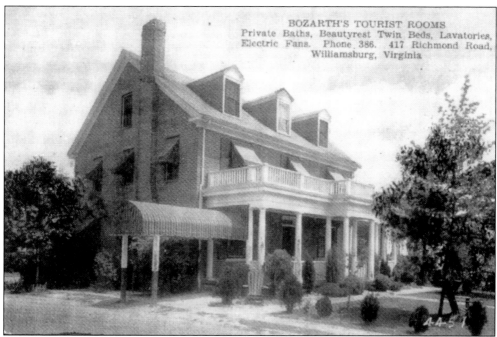

BOZARTH'S TOURIST ROOMS
Private Baths, Beautyrest Twin Beds, Lavatories,
Electric Fans. Phone 386. 417 Richmond Road,
Williamsburg, Virginia

Frank Bozarth and his wife, Mary, operated one of the first and largest tourist homes at 417 Richmond Road. According to this 1950s promotional postcard, it offered "private baths, Beautyrest twin beds, lavatories, electric fans."

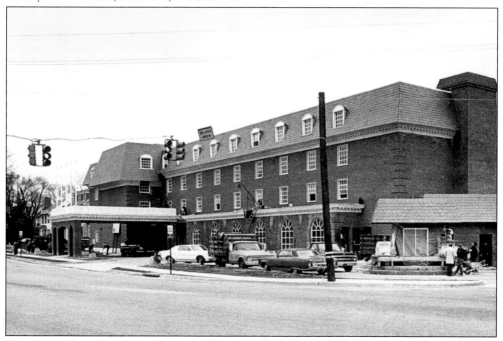

The Hospitality House was built in 1973 on Richmond Road between Virginia Avenue and Prince George Street, right. The site incorporated the Bozarth tourist home. Once construction got underway, city officials became alarmed by its massive appearance, although the builder, a Northern Virginia firm, complied with all city ordinances. (*Daily Press* photo.)

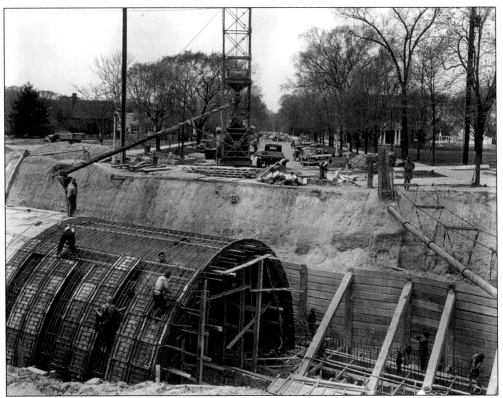

To permit traffic on the Colonial Parkway to pass through the Historic Area, a tunnel was built immediately prior to World War II. At that time the parkway ran between Yorktown and Williamsburg; the Williamsburg-Jamestown segment was opened in 1957. This photograph looks west down Duke of Gloucester Street toward the College of William and Mary. The columns on the porch of the Norton-Cole House, at the right, have since been removed. (Courtesy of The Colonial Williamsburg Foundation.)

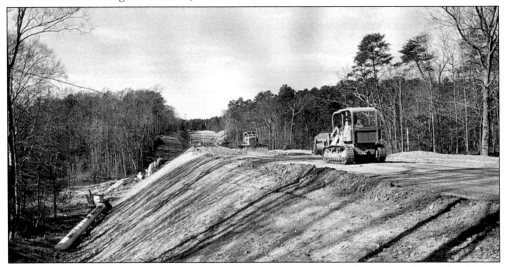

To permit traffic to pass around the Historic Area, Route 199 was built in 1973. This embankment under construction is over a culvert for Halfway Creek. (*Daily Press* photo.)

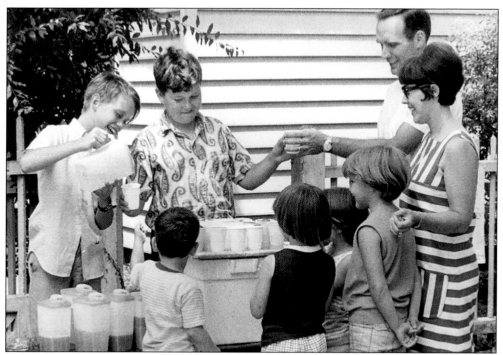

In July 1968, Chris Schlesinger, 12 (left), and Edmund Mitkievicz set up a lemonade stand on Duke of Gloucester Street— charging 10¢ a cup. This refreshing but unauthentic enterprise of "juvenile entrepreneurs" was shut down by Colonial Williamsburg. A few days later costumed employees opened an outdoor refreshment stand behind Chowning's Tavern. (*Daily Press* photo by Mary Goetz.)

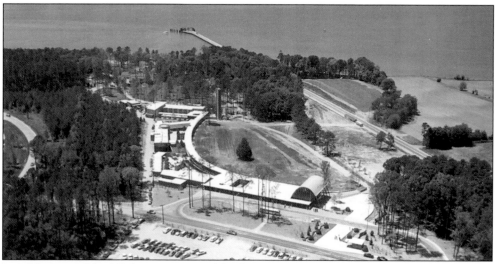

In celebration of the 350th anniversary of the first permanent English settlement at Jamestown, the commonwealth of Virginia built Jamestown Festival Park a mile upstream from Jamestown Island. The story of the colony was told in the Old World Pavilion and the New World Pavilion. Replicas of the three ships that brought the settlers and James Fort, all hidden beneath the foliage, are exhibited at the riverbank. The pier is that of the Jamestown-Scotland Neck ferry. (Photo by Thomas L. Williams.)

Five

"THE COMMON GLORY"

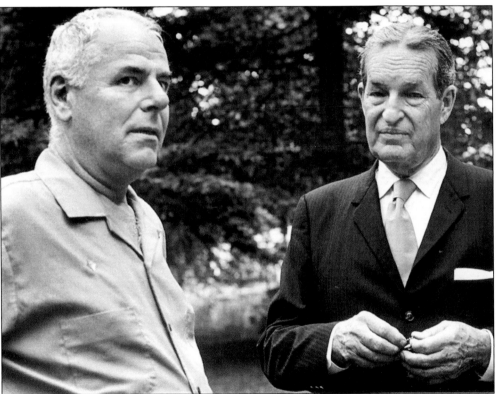

Howard Scammon (left) directed *The Common Glory*—the symphonic outdoor drama of the American Revolution written by Paul Green, right—for all but the first of its 28 seasons in Williamsburg. *The Glory* opened July 17, 1947, in the Lake Matoaka Amphitheatre on the campus of William and Mary and, after being dark for the 1964 and 1974 seasons, closed in 1976. Scammon was director of the William and Mary Theatre. Green, a Pulitzer Prize-winning playwright who lived in Chapel Hill, North Carolina, came to Williamsburg at the start of every summer season.

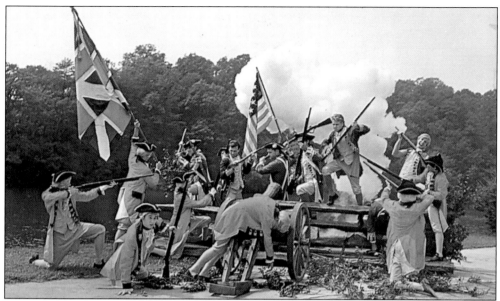

The climactic scene of *The Common Glory* was a dramatic staging of the Battle of Yorktown as Continental soldiers storm a British redoubt. The scene featured fireworks and a French frigate that sailed across the lake behind the stage. Walter H. Miller made the photograph for this postcard.

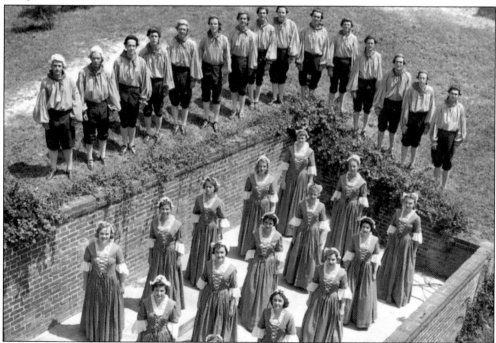

The 30-voice choir, composed of students from William and Mary and other colleges, was an essential part of the cast of *The Common Glory*. Here they pose for a publicity photograph on and above one of the two side stages at the Lake Matoaka Amphitheatre. Dr. Carl A. "Pappy" Fehr, director of the William and Mary Choir, directed the show's singers. (Photo by Thomas L. Williams.)

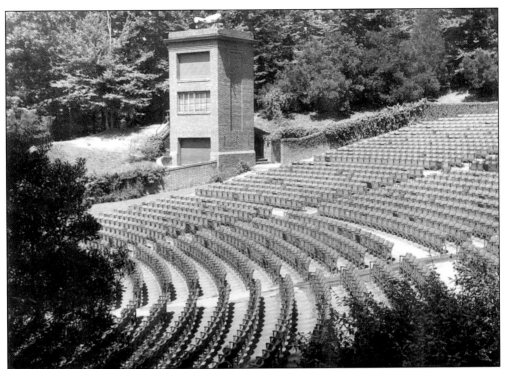

The 2,400-seat Lake Matoaka Amphitheatre was built especially for performances of *The Common Glory*. Towers flanked the seats from which stage managers directed amplified sound and lighting. An electric organ was rolled out from the sound tower, seen here. For many years a small symphony orchestra appeared on stage in some scenes.

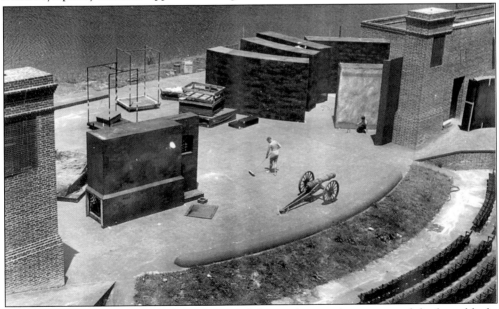

A stagehand sweeps the amphitheatre stage while another touches up one of the large blocks of scenery, which were on wheels and were silently moved about between acts. This picture was taken from the light tower.

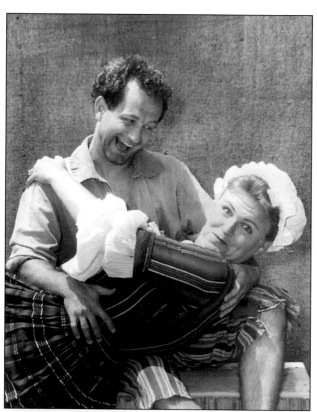

The comic roles of Cephus Sicklemore, a lovable ne'er-do-well, and the husband-hunting Widow Huzzitt are portrayed in this photograph by William Hicks and Edna Gregory.

Others who portrayed Cephus Sicklemore and the Widow Huzzitt were John Reese and Mamie Ruth Hitchens. The identity of the seated colonial is unknown. Among those whose stage careers were enhanced by the appearances in *The Common Glory* are Glenn Close, Linda Lavin, and Goldie Hawn.

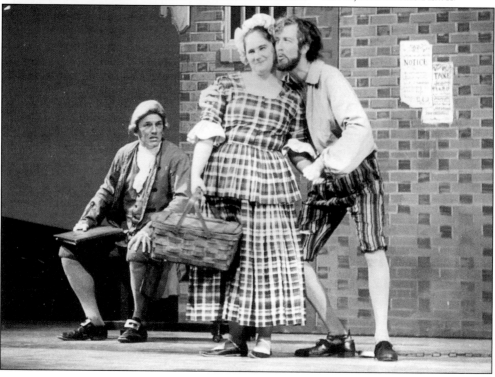

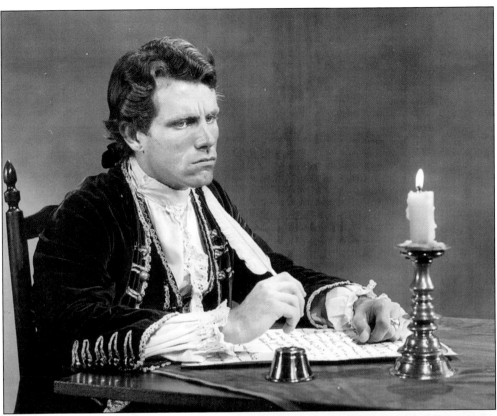

The leading character of Thomas Jefferson, seen here writing the Declaration of Independence, was held for many years by John Shearin, a Phi Beta Kappa graduate of William and Mary. Many of his lines are quotes of statements made by Jefferson when he was a Virginia delegate to the Continental Congress and governor during the Revolutionary War.

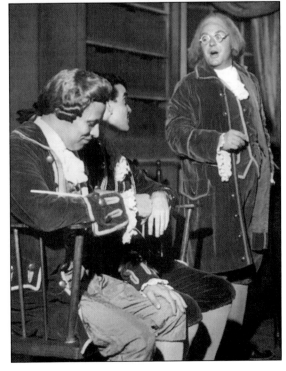

Several patriots are portrayed in *The Common Glory*, including Patrick Henry, Roger Sherman, John Adams, and Sam Adams. Here Ray Hilton (standing) assumes the role of Benjamin Franklin in the Philadelphia scene. The identities of the two seated performers are unknown.

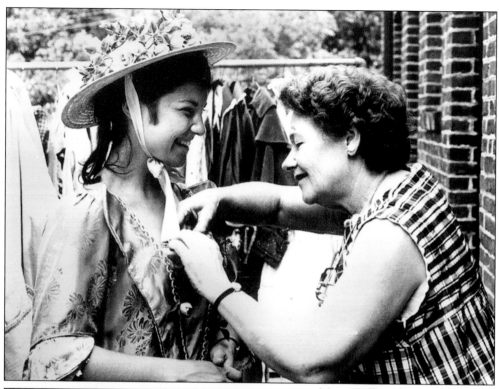

Many Williamsburg residents worked behind the scenes on productions of *The Glory*, among them Rachel Hitchens, the veteran costume mistress. Here she adjusts the bodice of a dress worn by Jody Deas, who portrayed Eileen Gordon, the daughter of a leading Tory. The romantic theme of the show involves Eileen and Hugh Taylor, a young patriot.

Paul Green wrote a new outdoor drama for the 1957 Jamestown Festival, *The Founders: The Story of Jamestown*, which that year was given in the afternoon in a rustic amphitheatre called The Coves. The leading roles of Pocahontas and John Rolfe were taken by a husband-and-wife team, June Deakins Moffatt and James Moffatt.

Six

VIP VISITORS

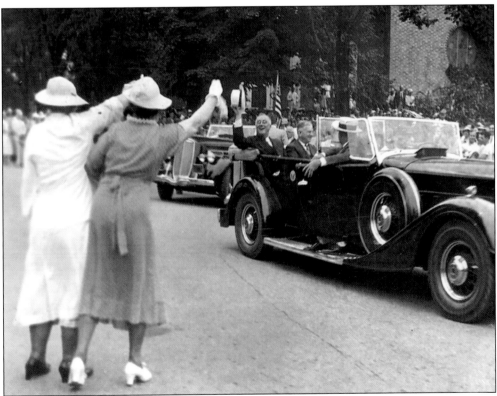

President Franklin D. Roosevelt waves enthusiastically from his touring car to two unidentified ladies who stepped out on Duke of Gloucester Street to greet him. Roosevelt was in Williamsburg on October 20, 1934, to participate in the inauguration of John Stewart Bryan as president of William and Mary. While in the city he proclaimed Duke of Gloucester Street "the most historic avenue in all America." Here his car passes Bruton Parish Church.

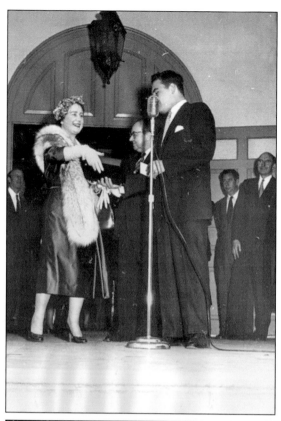

The Queen Mother Elizabeth smiles as she accepts a gift from Ronald I. Drake, president of the William and Mary Student Association, during her visit November 12, 1954, to the college campus. College President Alvin Duke Chandler is in the middle. To the right is Carlisle Humelsine, then executive vice president of Colonial Williamsburg, and British Ambassador Sir Roger Makins. Queen Elizabeth II and Prince Philip were in Williamsburg in October 1957 to mark the 350th anniversary of Jamestown. (*Daily Press* photo.)

Shirley Low, senior hostess for Colonial Williamsburg, escorts Jordan's King Hussein through a boxwood garden in April 1969 during the second of his four visits to Williamsburg. They are trailed by Jordanian and American diplomats. Hussein was much taken with Williamsburg and made a determined effort to visit the Historic Area just before he died in 1998. (*Daily Press* photo by Mary Goetz.)

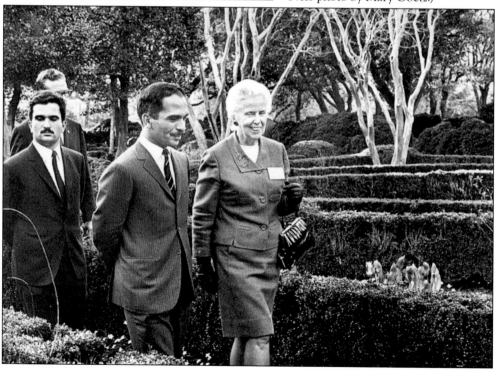

Kenneth Chorley, president of Colonial Williamsburg, escorts Winston Churchill through the garden behind the Governor's Palace. The wartime British prime minister was in Williamsburg March 8, 1946, along with Gen. Dwight D. Eisenhower, after addressing the Virginia General Assembly in Richmond. A few days prior to that Churchill gave his famous "An Iron Curtain Has Fallen" speech in Fulton, Missouri. (Colonial Studios; courtesy of Vernon M. Geddy Jr.)

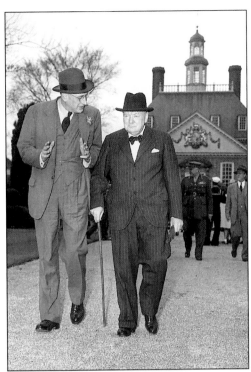

Vernon M. Geddy Sr., executive vice president of Colonial Williamsburg, walks with Clementine Churchill, wife of Winston Churchill, along Palace Green on September 8, 1943. With them is the Churchill's daughter, Mary, then a subaltern in the British army. While they were in the Raleigh Tavern, word reached them that Italy had capitulated. (Courtesy of The Colonial Williamsburg Foundation.)

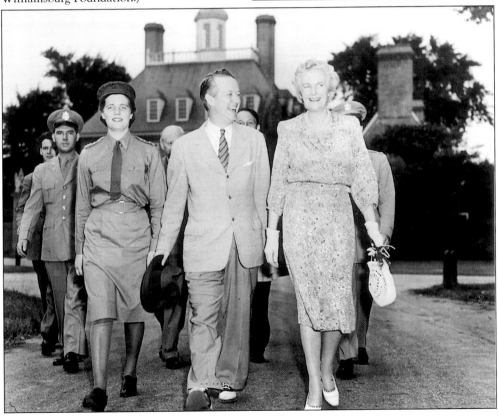

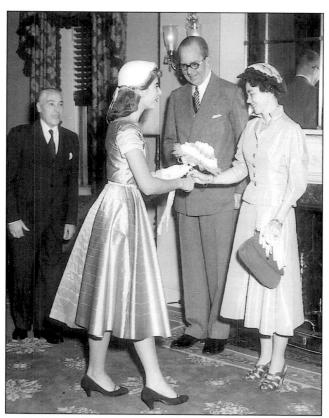

Kecha Costas, daughter of Angelo and Dora Costas of Williamsburg, presents a bouquet to Queen Frederika of Greece as King Paul stands by. Alexander Sacalis is at the left. The royal couple visited Williamsburg in November 1953. (Photo by Douglas B. Green II; courtesy of Elizabeth Sacalis.)

Duncan M. Cocke, vice president of Colonial Williamsburg, chats with Indira Gandhi, prime minister of India, before her ride through the Historic Area in a horse-drawn carriage. Mrs. Gandhi was in Williamsburg in March 1966 prior to meeting in Washington with President Johnson and addressing the United Nations in New York. (*Daily Press* photo.)

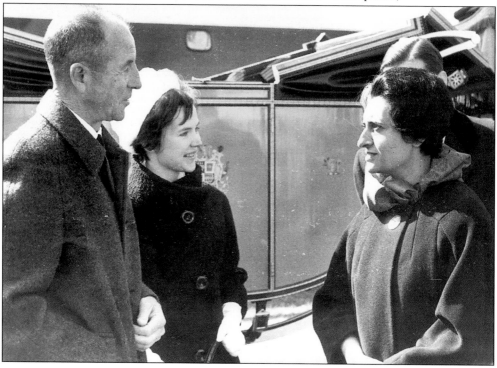

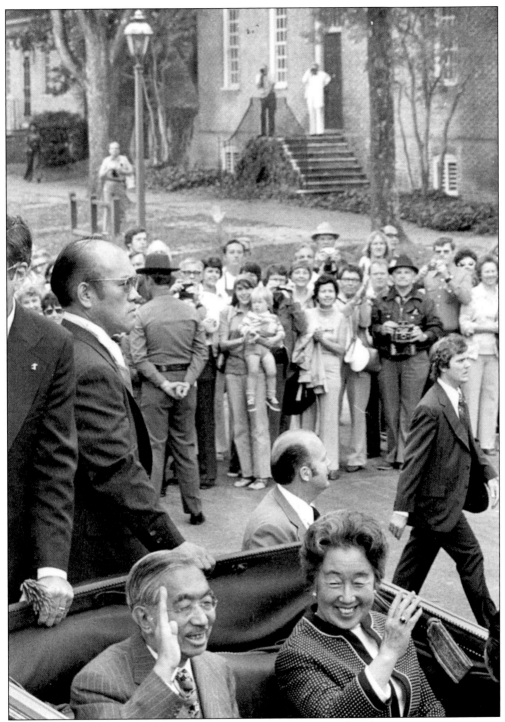

Emperor Hirohito and Empress Nagako of Japan wave to a crowd as their carriage swings onto Duke of Gloucester Street. The steps of the Ludwell-Paradise House are in the background. The royal couple stayed in the Williamsburg Inn in September 1975. Their son, Akihito, now emperor, visited Williamsburg in 1953.

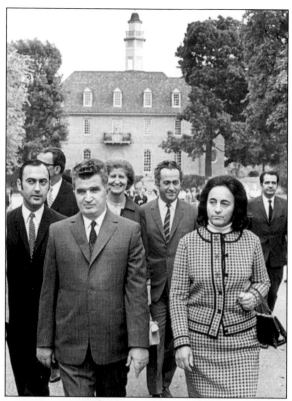

The October 1970 visit of Romanian President Nicolae Ceausescu and his wife, seen here with their entourage leaving the colonial Capitol and walking down Duke of Gloucester Street, included a pick-up game of volleyball in the back yard of the Allen Byrd House. (*Daily Press* photo by Mary Goetz.)

Some of the participants in the Romanian-U.S. volleyball game pose with Carlisle Humelsine, third from the left, president of Colonial Williamsburg, and his wife, Mary. The trio of victorious Romanian diplomats is unidentified. To the right of Mrs. Humelsine are Dick Sessoms, director of special events for Colonial Williamsburg, and Norm Beatty, director of the Colonial Williamsburg press bureau. (*Daily Press* photo by Mary Goetz.)

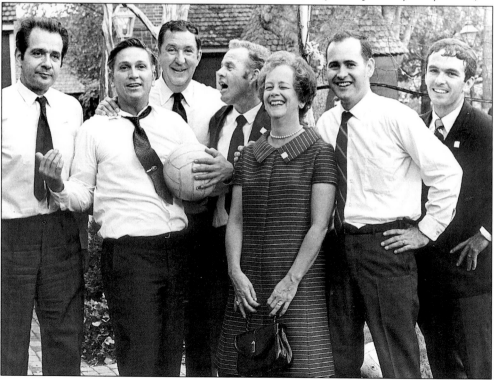

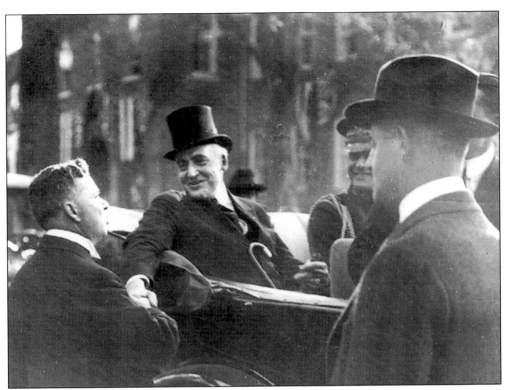

President Warren G. Harding spent October 19, 1921, commemorating the 140th anniversary of Washington's victory over Cornwallis at Yorktown by visiting Jamestown Island and receiving an honorary degree from William and Mary. Here he is welcomed to the campus by college Pres. Julian Alvin Carroll Chandler.

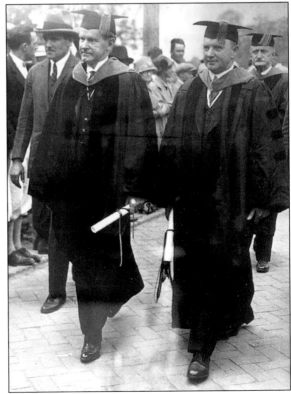

President Calvin Coolidge, wearing the traditional academic cap and gown, holds his honorary doctor of laws degree from William and Mary as he leaves the platform. With him is Gov. Harry F. Byrd Sr. It was estimated that 8,000 persons were on hand May 15, 1926. (P. and A. Photos Inc.; courtesy The Colonial Williamsburg Foundation.)

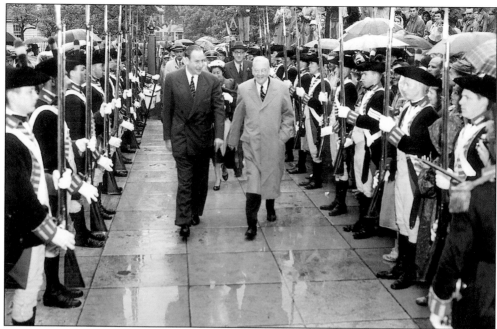

Sec. of State John Foster Dulles (right) is escorted by Winthrop Rockefeller, board chairman of The Colonial Williamsburg Foundation, past the salutes of the Monticello Guard of Charlottesville as they enter the reconstructed colonial Capitol of Virginia on May 15, 1954. Dulles delivered a speech emphasizing the need of the United States to challenge the aggressiveness of the Soviet Union. (Photo by Thomas L. Williams; courtesy The Colonial Williamsburg Foundation.)

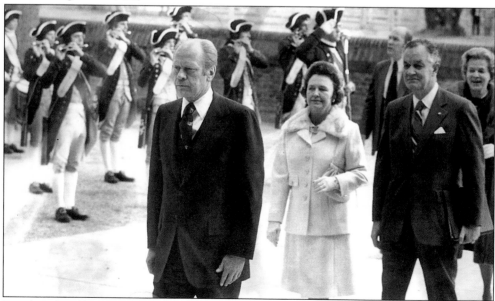

President Gerald Ford precedes Gov. and Mrs. Mills E. Godwin Jr. as they enter the reconstructed colonial Capitol for a January 31, 1976, commemorative session of the Virginia General Assembly. Ford returned to Williamsburg in October for a presidential campaign debate at William and Mary with his Democratic challenger, Jimmy Carter.

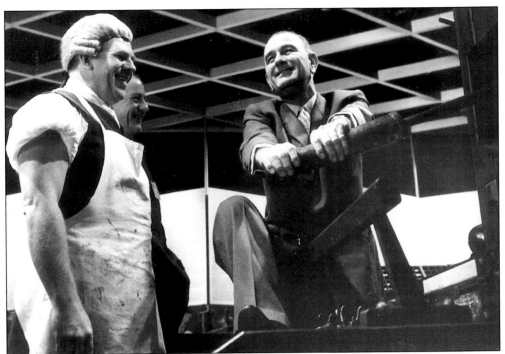

Vice president-elect Lyndon Baines Johnson pulls the rat's tail of a colonial press to print a ceremonial copy of the Virginia Declaration of Rights. Johnson was in Williamsburg in November 1960 to speak to a conference of the Associated Press Managing Editors. Gus Klapper is the colonial printer. (*Daily Press* photo.)

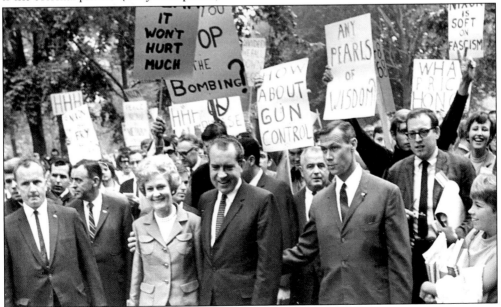

President Richard M. Nixon and his wife, Pat, appear undisturbed by the dissenting placards that marked an anti-Nixon demonstration during his October 2, 1968, visit to the College of William and Mary. Nixon was campaigning for re-election and spoke inside the Wren Building to an audience of invited guests. (*Daily Press* photo via the Associated Press.)

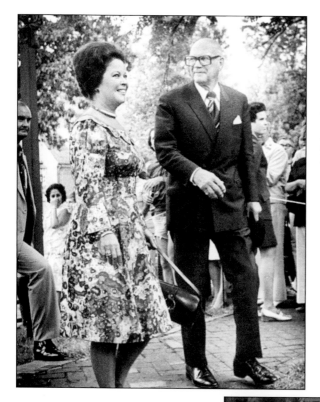

Shirley Temple Black, U.S. chief of protocol, stole the spotlight from the president of Finland, Urho Kekkonen, when he spent two days in Williamsburg in August 1976. As a child movie star, Shirley Temple visited Williamsburg and was given a party by local girls to celebrate her birthday. (*Daily Press* photo by Mary Goetz.)

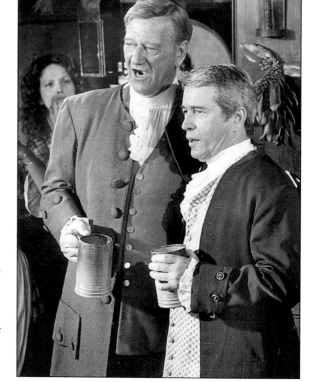

John "Duke" Wayne and Perry Como strike a melodic pose in Chowning's Tavern during the taping of a 1978 Christmas television special. As many as 400 persons gathered outside the tavern to catch a glimpse of the Western film star and crooner. (*Daily Press* photo by Michael D. Asher.)

Seven

CELEBRATIONS

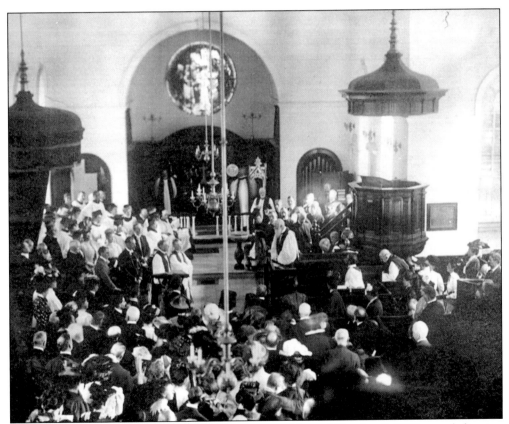

The first restoration of Bruton Parish Church was celebrated October 5, 1907, at a dedication service led by the presiding bishop of the Episcopal Church, the Right Rev. Daniel Sylvester Tuttle. On that occasion the church received a Bible given by King Edward VII and a lectern to hold it given by President Theodore Roosevelt. A second restoration was carried out in 1939.

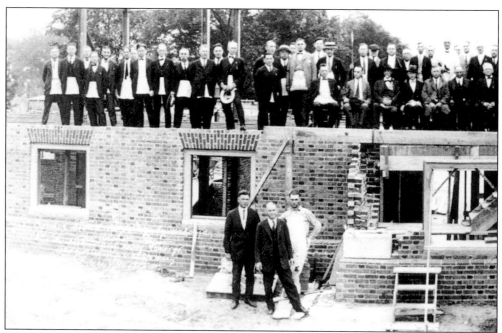

Members of Williamsburg Lodge No. 6 of Ancient Free and Accepted Masons gathered June 9, 1924, to lay the cornerstone for the George Blow Memorial Gymnasium on the William and Mary campus. The principal speaker was the Rev. W.A.R. Goodwin, who at that time headed the college's endowment campaign. (Courtesy of College of William and Mary Archives.)

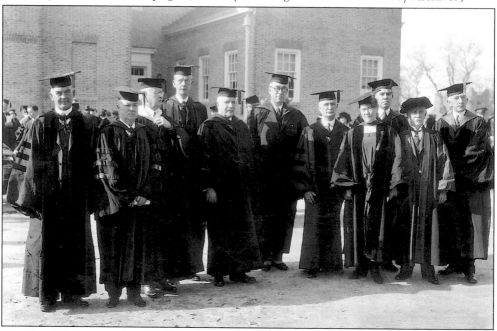

The Rev. W.A.R. Goodwin (left) and William and Mary Pres. J.A.C. Chandler (second from the left) were among the dignitaries at the dedication of Phi Beta Kappa Memorial Hall on November 26, 1926. Also present but not in this photograph was John D. Rockefeller Jr. The national honorary academic society was founded at William and Mary in 1776.

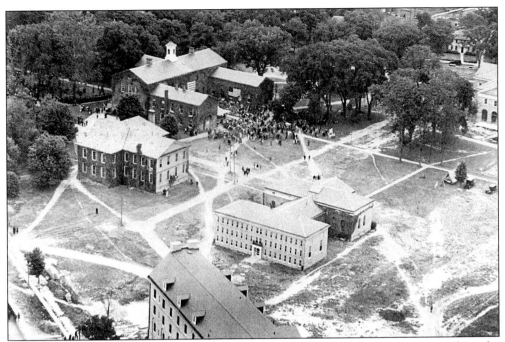

Crowds gathered at the rear of the Wren Building on May 15, 1926, for a ceremony marking the 150th anniversary of the Virginia Resolves for Independence. President Calvin Coolidge was the principal speaker. The H-shaped building is the college library; the building to the left is a science hall that was demolished in 1932. Note the first aid station by the lone tree. (Courtesy of U.S. Army Signal Corps.)

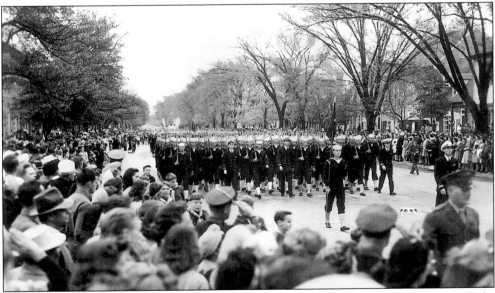

Sailors from nearby Camp Peary, a World War II training center for Seabees, march down Duke of Gloucester Street in a Navy Day parade on October 26, 1943. The observance concluded with a radio address by Gov. Colgate W. Darden to an outdoor assembly at William and Mary. The college served as wartime host to a Navy school for chaplains. (Photo by Thomas L. Williams.)

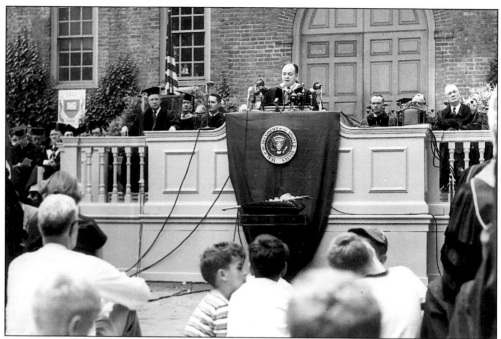

President Dwight D. Eisenhower, seated under the flag, attended the May 15, 1953 induction of Alvin Duke Chandler as president of William and Mary. A number of boys from the neighborhood, seated on the lawn before the college mace, appear to be oblivious to the proceedings. Chandler is at the podium. (*Daily Press* photo by Bea Kopp.)

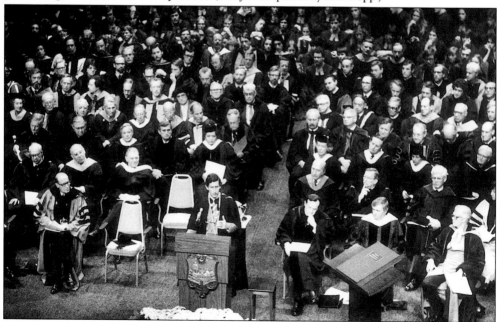

A packed house in Phi Beta Kappa Hall listened to Prince Charles on May 3, 1981. Seated at the left and in front of the faculty is college Pres. Thomas A. Graves Jr. and to the right is Gov. John Dalton, an alumnus. Prince Charles returned in 1993 to celebrate the college's 300th anniversary. (*Daily Press* photo by Joe Fudge.)

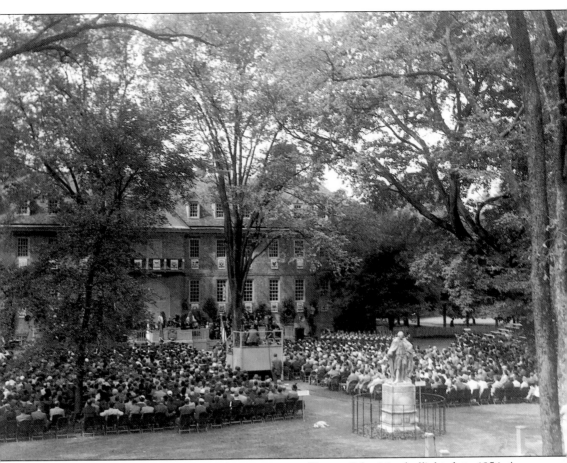

William and Mary celebrated the 200th anniversary of Justice John Marshall's birth in 1954. At this September 25 convocation in front of the Wren Building, busts were unveiled of Marshall, "the Father of American Constitutional Law;" George Wythe, who at William and Mary held the first chair of law in America and was Thomas Jefferson's teacher; and Sir William Blackstone, whose *Commentaries on the Laws of England* influenced the thinking of the framers of the U.S. Constitution. Participants were Chief Justice Earl Warren and Lord Goddard, chief justice of England, both of whom received honorary degrees. A stand for news photographers occupied the walkway between the statue of Lord Botetourt and the speaker's platform. Note the campus dog sleeping behind the last row of seats.

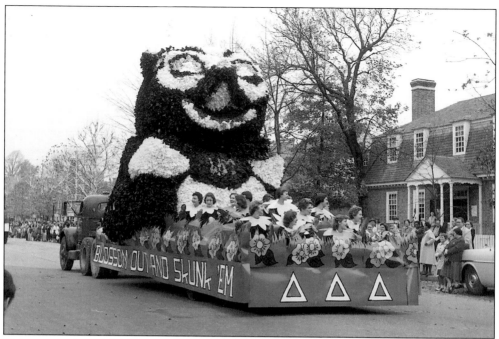

Elaborate papier-mâché floats, such as this one made by members of Delta Delta Delta social sorority, were the highlight of William and Mary homecoming parades in the 1950s. Less elaborate and less costly floats have been featured in more recent years. This float's slogan reads "Blossom out and skunk 'em."

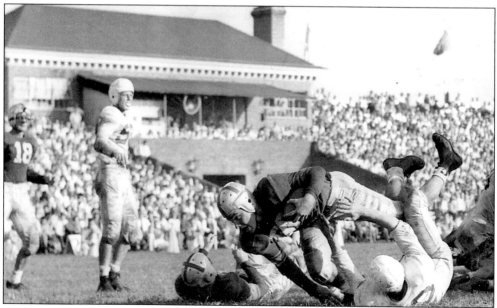

One of the most memorable football games played in Cary Field Stadium was against the University of North Carolina on October 18, 1947. Led by Charles "Choo Choo" Justice, the nationally ranked Tar Heels won 13-7. Here, All-American fullback "Flyin'" Jack Cloud scores William and Mary's only touchdown. For the season, W&M was 9-2. (Courtesy of Fred Frechette.)

John D. Rockefeller III, chairman of the Colonial Williamsburg board, and two hostesses, Mildred "Midge" Adolph (left) and Winifred Mackey (right), participate in the first observance of the Prelude to Independence at the colonial Capitol. The observance, begun in 1951, marked the May 15, 1776, passage of the Virginia Resolves for Independence and other legislative activity that led to the Declaration of Independence. (Photo by Thomas L. Williams.)

Always ready to celebrate with song are The Dukes of Gloucester Street, whose members in January 1970 included, from left to right, (seated) Don Parker, Dave Stanford, Ann Rowe, and Jim Anthony; (standing) Dick Sessoms, Dan Brown, George Cooper, Bill Holland, Elmore Hitchings, Herb Deppe, Cal Page, Dennis Cogle, Scott Hester, and Charlie Laird.

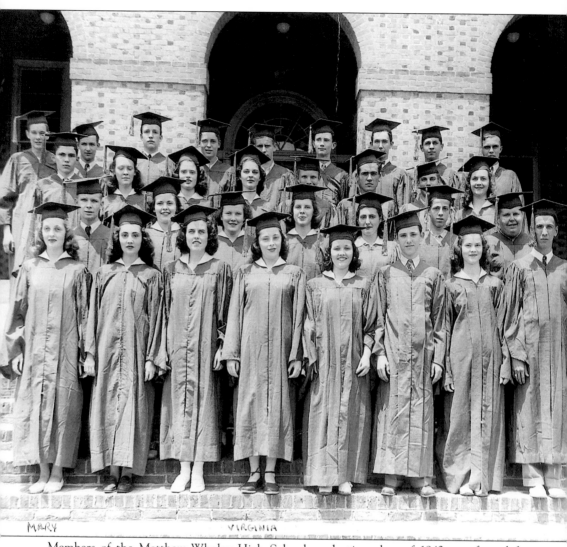

MARY VIRGINIA

Members of the Matthew Whaley High School graduating class of 1943 are, from left to right, (first row) Mary Sacalis, Betty Badkins, Catherine Thonesen, Virginia Sacalis, Helen Boyce, Guy White, Mildred Payne, and Jeff Carter; (second row) Waverly Portewig, Shirley Porter, Helen Young, Mary Libby Keller, Mary Alice Holland, Baxter Bell, and Buck Bingley; (third row) Arthur Thompson, Janet Campbell, Evelyn Stryker, Barbara Duborg, Joe Hall, Louis Waltrip, Dick Schaus, and Doris Steele; (fourth row) Milton Raley, Leslie Chalkley, Channing Hall, Vernon Geddy, William Geiger, Clarence Belvin, Joe Terrell, Roy Scott, and Austin Wright. Both Hall and Geddy were elected to the City Council and Geddy served as mayor. Bell, following in his father's footsteps, was a prominent physician. (Courtesy of Elizabeth Sacalis.)

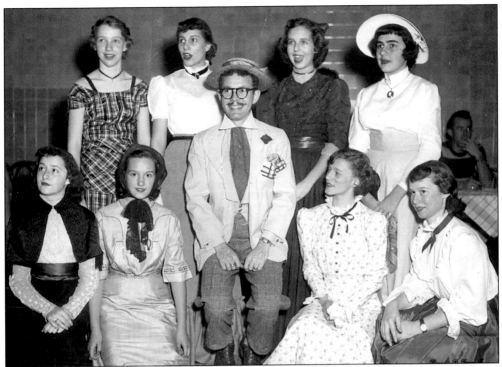

Teacher Bill Etheridge was the center of attention when these coeds paused to pose for the photographer at a 1950 Gay Nineties Dance in the Matthew Whaley School cafeteria. They are, from left to right, (seated) Georgea Ryan, Dorothy Frazier, Langhorne Mills, and Maureen Philips; (standing) Lester Ann Sykes, Kecha Costas, Honey Page, and Claudine Carew. (Courtesy of Bill Etheridge.)

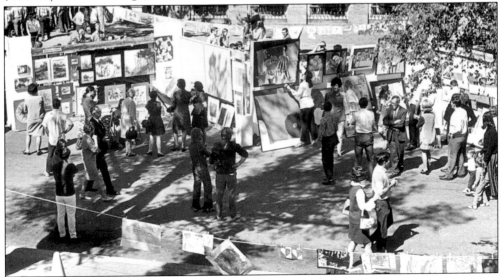

The older of two outdoor art shows held annually on Merchants Square is the spring exhibition staged by the Junior Woman's Club. In the early years, zigzag walls were erected for the artists' displays. In this undated photo, children's works were hung from clothes lines stretched between trees. The other show, An Occasion for the Arts, is held the first Sunday of October.

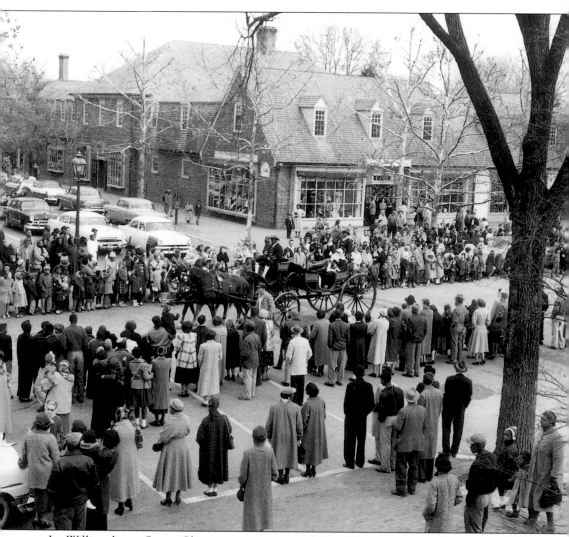

In Williamsburg, Santa Claus sometimes arrived by Colonial Williamsburg's horse-drawn carriage. In this 1956 photo St. Nick passes Casey's Department Store as Jake Keyser walks alongside the horses. The Williamsburg Area Chamber of Commerce stages the annual Christmas parade on the first Saturday in December.

Eight

GROUPS

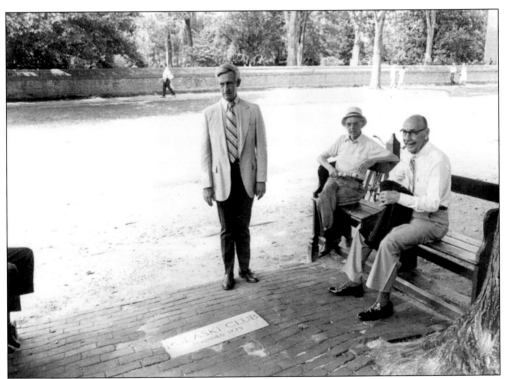

The Pulaski Club, which dates from 1779, meets on the benches in front of the Cole Shop on Duke of Gloucester Street. Membership is limited to 31, the age of Count Casimir Pulaski at his death, and its main purpose is to protect and prolong the fine arts of discussion and storytelling. At the benches here are George Wright, standing, and Thomas A. Moyles, seated left. The third man is an invited interloper, Richard A. Henson, president of Henson Airlines, who happened by.

Organizers of the Williamsburg Reunion, held every other year by people who lived in Williamsburg at least 40 years ago, are, from left to right, Elizabeth Lee Henderson, Janet Coleman Kimbrough, John W. Henderson, and Suzanne Garrett Montague. The first reunion was held in 1968.

The Madrigal Singers, organized in 1960, present programs of madrigals, motets, catches, and glees of the 16th and 17th centuries. This 1969 photo, shows, from left to right, Herbert Deppe, Beverly Kelly, Robin Roark, Pat Deppe, and Marion Wilson.

A commission appointed to study the possibility of consolidating the city of Williamsburg and the county of James City concluded in 1963 that it was plausible but not necessarily desirable. Making that determination were, from left to right, (seated) Sam Hazelwood Jr., Lee Robbins, Bob Evans and G.T. Brooks Jr.; (standing) Ralph Cobb, Thomas Atkinson, Hugh Rice, and Murray Loring.

A group organized in the 1950s to study recreational activities was composed of, from left to right, Owen Latham, Johnny Hedgepath, H.M. Stryker, G.T. Brooks Jr., unidentified, Al Helslander, Lloyd Haynes Williams, unidentified, Frank Cody, unidentified, and Pete Babcock. (Photo by George Von Dubell.)

Roger Leclere, standing left, chairman of the Williamsburg Library Board, opens a 1970 public hearing before the city council on the location of the new library, a controversial issue at that time. Councilmen with their backs to the camera are, from left to right, Robert Hornsby, Vincent D. McManus, and Vernon M. Geddy Jr. Sitting in the front row are, from left to right, Thomas N.P. Cutler, Shirley Low, J. Wilfred Lambert, Joe Phillips and Wilson B. Skinner

Sr. Seen between Cutler and Low are Donald Gonzales and Col. Giles R. Carpenter. Seated between Lambert and Phillips is Dr. Beryl Parker, who lived on Scotland Street opposite where the library was built. Seen behind Skinner's outstretched arm is John Kinnier, long-time reporter for the Richmond *Times-Dispatch*. Directly behind him is Alice B. Alexander and behind her is Police Chief Andrew Rutherford. (*Daily Press* photo.)

School Superintendent Rawls Byrd takes the controls of a Caterpillar tractor to break ground for a school that was later named for him. On hand, from left to right, were members of the Williamsburg-James City County School Board, Hammond Branch, Norman Hornsby, Champ Y. Powell, and John Harbour. (*Daily Press* photo.)

Attending the groundbreaking of the Williamsburg-James City Courthouse built in 1967 were, from left to right, an unidentified architect; City Councilman Channing M. Hall Jr.; City Manager Frank Force (partially hidden); Councilman Vincent D. McManus; Fred Flannary, a member of the county board of supervisors; Garland Wooddy, county executive secretary; Circuit Judge Robert T. Armistead with shovel; Councilman Y.O. Kent; Mayor H.M. Stryker; Supervisor Murray Loring; David Henderson, the contractor; and an unidentified man. (*Daily Press* photo.)

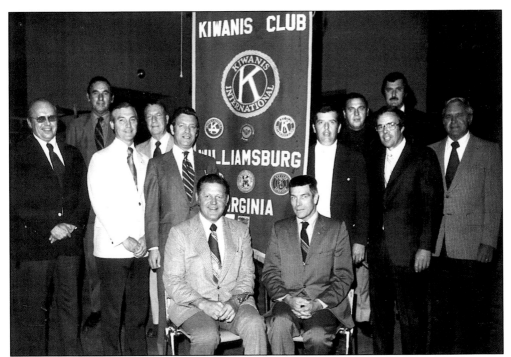

Past presidents of the Williamsburg Kiwanis Club gathered in 1974 for this photo. They are, from left to right, (seated) Norman Hornsby and Bill Jacobs; (standing) Jack Walklet, Ted Devitt, Curtis Watkins, Ran Ruffin, Jim Anthony, Don Bentley, Phil Richardson, David Otey, G.T. Brooks Jr., and Ed Derringe. (Courtesy of Gil Granger.)

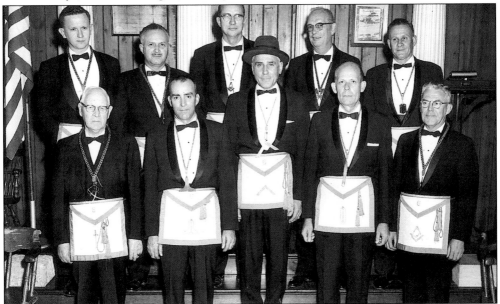

Leaders of Williamsburg Lodge No. 6, AF&AM in this undated photo are, from left to right, (front row) Boyd Creasy, Charles Carteret, Joe Gulasky, unidentified, and Lyman Peters; (back row) Jack Corrigan, unidentified, Roy Pugh, Robert Evans, and Norman Harmon. (Photo by Thomas L. Williams.)

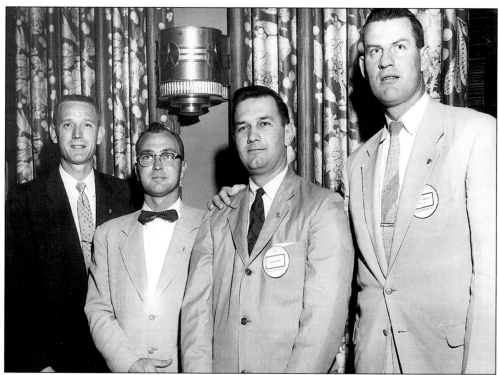

Leaders of the Williamsburg Jaycees in this undated photo are, from left to right, Ed Spencer, Ben Cato, Jim Freeman, and Dick Forest. (*Daily Press* photo.)

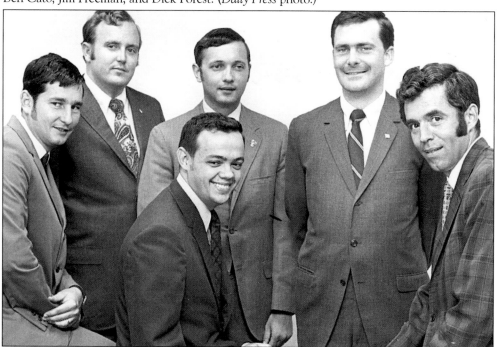

Another group of Jaycee officers are, from left to right, Tom Noblin, Dave Hannafourde, Lenny McMaster (seated), Bob Lent, Gil Bartlett, and Leonard Melfi. (*Daily Press* photo.)

Llew Smith, seated and wearing a bow tie, served as president of the Jaycees in 1968. Other officers were, from left to right, (seated) John Donaldson, Doug White, and Tommy Smith; (standing) Rudy Johnston, Gil Granger, Tom Campbell, Roy Aycock, Tommy Noblin, Marty Nosal, unidentified, and Max Tongier. (Photo by Thomas L. William.)

Gathered to lead a $500,000 fund-raising campaign for an addition to Williamsburg Community Hospital are, from left to right, (seated) Robert C. Walker and William Person, co-chairmen; J.B. Hickman; and Champ Y. Powell; (standing) Donald Gonzales; the Reverend Thomas Pugh, who was president of the hospital board; Thomas N.P. Cutler; Robert Vermillion; Stuart C. Will; and Dewey C. Renick. (Photo by Thomas L. Williams.)

Getting ready to distribute pledge cards for the Williamsburg-James City County United Fund are three community leaders, from left to right, Duncan Cocke, vice president of Colonial Williamsburg; Robert Walker of the Peninsula Bank, who later served as Williamsburg's mayor; and Norman Hornsby, who, among other leadership positions, was president of the Williamsburg Chamber of Commerce. (*Daily Press* photo.)

Leaders for another fund drive gather around Carol DeSamper, who from 1970 until 1987 was executive director of the United Way of Greater Williamsburg. They are, from left to right, (standing) Al Morgan, Jack Coffman, William B. Guerrant, William Pfeiffer, and C.C. McElheny; (seated) Warren Heemann and Robert Kramer. (Photo by Thomas L. Williams.)

Nine

NEWSMAKERS

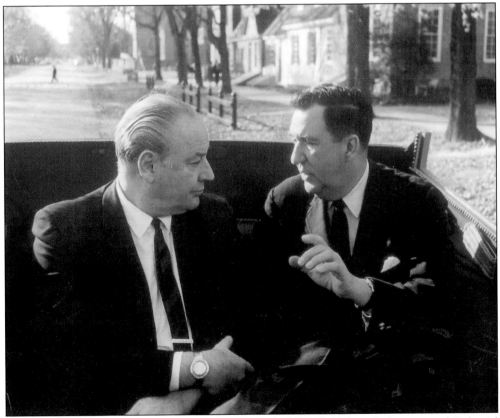

Holding a carriage conference are Winthrop Rockefeller (left) board chairman of Colonial Williamsburg from 1953 until 1973, and Carlisle H. Humelsine, president from 1958 until 1977. Rockefeller succeeded his brother, John D. Rockefeller III, who served from 1939. Humelsine was board chairman from 1977 until 1985. (Courtesy of The Colonial Williamsburg Foundation.)

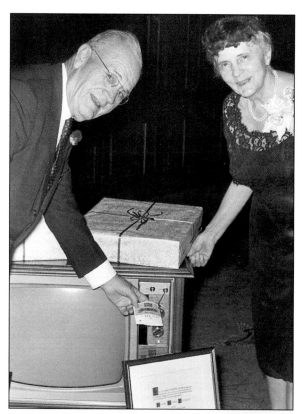

The community honored Dr. Henry Morris Stryker and his wife, Fannie Lou Gill Stryker, on September 19, 1969. He retired after serving 34 years on the Williamsburg City Council. Among the gifts they received was a color television set. Dr. Stryker, a much-beloved dentist whose nickname was Polly, was mayor from 1948 until 1968. (*Daily Press* photo.)

Dr. H.M. Stryker enjoys a laugh with Carrie Cole Geddy (right)the widow of Vernon M. Geddy Sr., and her daughter, Caroline Geddy Frechette. Stryker was a regular Sunday visitor in the Geddy household. (Courtesy of Fred L. Frechette.)

Apparently affable campaigners in 1972 for the local seat in the Virginia General Assembly are Russell M. Carneal (standing), an attorney who represented Williamsburg and James City County from 1954, and George Grayson, a professor of government at William and Mary. Grayson defeated Carneal and took his seat in the legislature in 1973 and held it into the 21st Century. (*Daily Press* photo.)

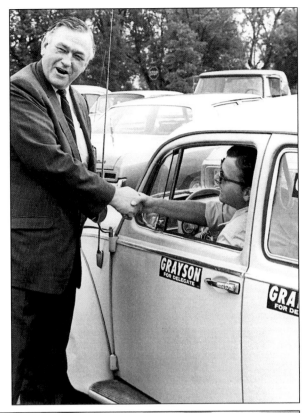

After leaving the General Assembly, Carneal was appointed a general district judge in 1974. Here, he and J.R. Zepkin, also appointed to the bench that year, take the oath of office from Juliette Clothier, clerk of the Williamsburg-James City County Circuit Court. (*Daily Press* photo by Mary Goetz.)

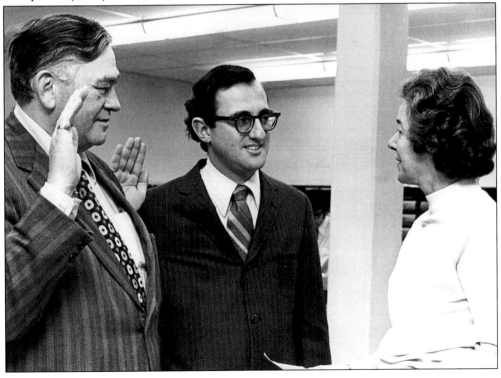

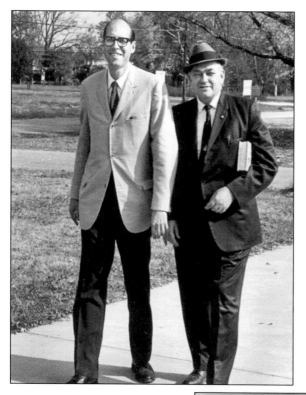

In 1977, Carneal (right) was appointed judge of the ninth judicial circuit, succeeding Robert T. Armistead. He retired in 1989. With him is William L. Person, commonwealth's attorney for Williamsburg and James City County from 1964 until 1989 when he was appointed circuit judge, succeeding Carneal. Person retired in 1997. (*Daily Press* photo.)

Virginia Timberlake Blanchard retired as clerk of the Williamsburg-James City County Circuit Court in 1966 after serving in that position since 1928. She went to work in the clerk's office in 1907. At that time the clerk was Thomas H. Geddy.

Vernon M. Geddy Sr., an attorney who was the son of Thomas H. Geddy, was hired by the Rev. W.A.R. Goodwin to carry out legal work associated with the purchase of property in the Historic Area. Vernon Geddy joined the administration of Colonial Williamsburg in 1930. Here he is leaving old Phi Beta Kappa Hall in 1951, shortly before he died. (Courtesy of Fred L. Frechette.)

Vernon M. Geddy Jr. followed his father in the practice of law. He was mayor of Williamsburg from 1970 until 1980 and served on the Colonial Williamsburg board. (*Daily Press* photo by Mary Goetz.)

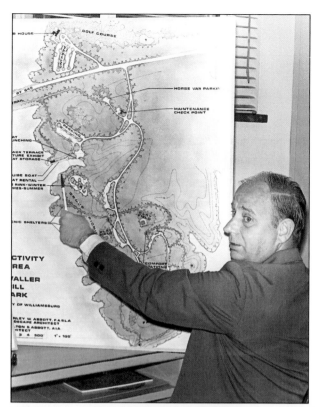

Among the community leaders who were born in Williamsburg was William Dow Geiger, who, as a member of the city planning commission, was involved in the building of Waller Mill Park. Geiger also headed the city's Civil War Centennial Commission. He was director of craft shops for Colonial Williamsburg and was instrumental in organizing the fife and drum crops and company of militiamen.

Edward D. Spencer Jr., another native of Williamsburg and a graduate of William and Mary, was director of museum services for Colonial Williamsburg. At one time during his career he was manager of the Information Center and, as such, helped direct traffic on a busy summer day. (*Daily Press* photo.)

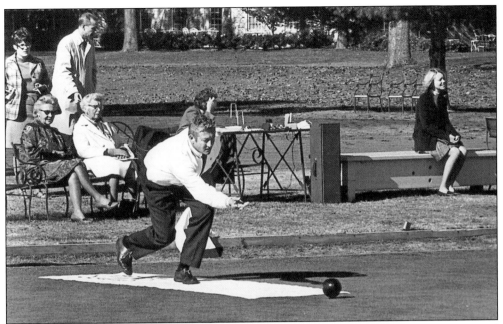

Richard D. Mahone, a native of Williamsburg, was director of landscape construction and maintenance for Colonial Williamsburg, and was responsible for gardens and woodlands, greenhouse and nursery operations. Here he participates in a lawn bowling competition on the court behind the Williamsburg Inn. (*Daily Press* photo.)

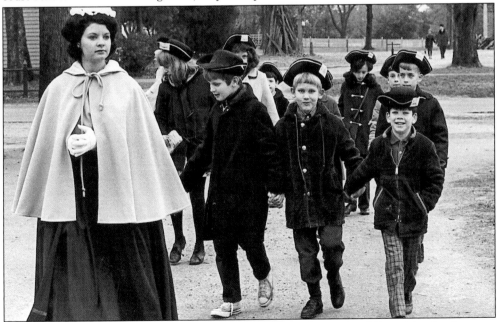

Gwen Phillips Hinton is one of many Williamsburg residents who followed in the footsteps of their parents and worked for Colonial Williamsburg. As a college student she led Tricorn Hat tours of students through the Historic Area. Her parents, Leroy and Hildegarde, retired from Colonial Williamsburg—he as a draftsman and she from the personnel office. (*Daily Press* photo.)

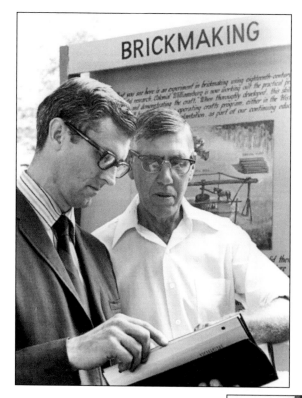

Checking out details in the making of bricks is Earl Soles (left), director of the crafts program for Colonial Williamsburg, and James Maloney (right), a skilled potter and the founder of the Williamsburg Pottery at Lightfoot. (*Daily Press* photo by Mary Goetz.)

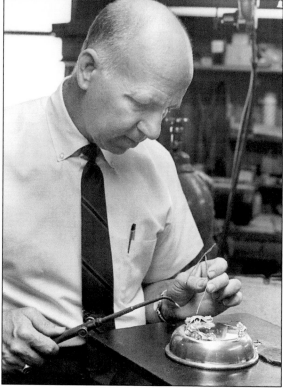

Shirley Robertson served for a while on the Williamsburg police force but his interest was in making pewterware. He established Shirley Metalcraft for the manufacture of pewter bowls, candlesticks, mugs, and Jefferson cups. (*Daily Press* photo by Mary Goetz.)

Parke S. Rouse Jr. was the biographer of the Rev. James Blair, founder of the College of William and Mary, and author of a dozen other books of Virginia history. Several of them were collections of columns he wrote for the *Daily Press*. He was director of the 1957 Jamestown Festival and afterwards director of Jamestown Festival Park. (*Daily Press* photo by Mary Goetz.)

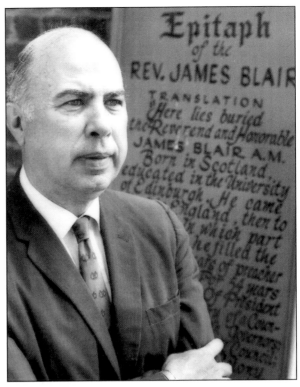

Among the many writers who have lived in Williamsburg was Burke Davis, author of A *Williamsburg Galaxy*, but better known for his biographies of Robert E. Lee, Thomas J. "Stonewall" Jackson, Jeb Stuart, Andrew Jackson, Gen. Billy Mitchell, Gen. Lewis B. "Chesty" Puller, and others. (*Daily Press* photo by Mary Goetz.)

Ivor Noel Hume left his native England to direct the archaeology program for Colonial Williamsburg and as such led the excavations of many historically significant sites in the Williamsburg area, including the Public Hospital of 1773 and Martin's Hundred on the James River at Carter's Grove. He is also the author of *Here Lies Virginia* and several other books on Virginia archaeology and history. (*Daily Press* photo by Mary Goetz.)

Among the many skilled craftsmen who worked in the Historic Area was C. Clement Samford, a bookbinder in the printing office. Samford also wrote music reviews for the *Daily Press*. (*Daily Press* photo by Mary Goetz.)

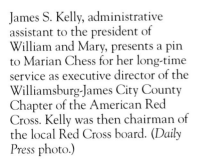
James S. "Jock" Darling, organist and choirmaster for Bruton Parish Church, has for years given weekly recitals in the church and in the chapel of the Wren Building. He also teaches at the College of William and Mary and is a music consultant for Colonial Williamsburg. (*Daily Press* photo by Mary Goetz.)

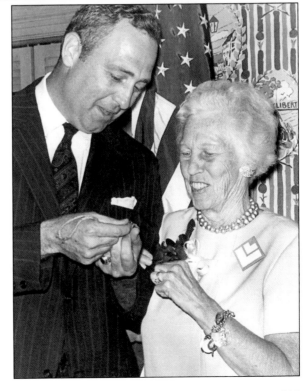

James S. Kelly, administrative assistant to the president of William and Mary, presents a pin to Marian Chess for her long-time service as executive director of the Williamsburg-James City County Chapter of the American Red Cross. Kelly was then chairman of the local Red Cross board. (*Daily Press* photo.)

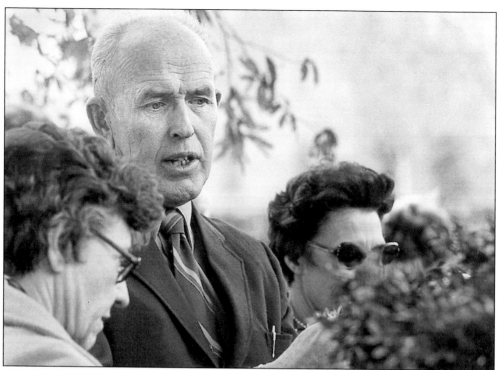

Alden R. Eaton was instrumental in the development of the gardens for Colonial Williamsburg and in founding its Garden Symposium, held annually for 55 years. He was vice president and director of construction and maintenance for Colonial Williamsburg. (*Daily Press* photo by Mary Goetz.)

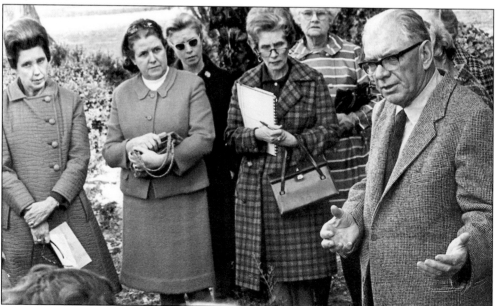

John T. Baldwin, professor of biology at William and Mary, was responsible for the planting of several unusual species of trees and plants on the college campus. Here he conducts a tour for members of a garden club. (*Daily Press* photo by Mary Goetz.)

Thessalonians Judkins was the senior waiter at the Williamsburg Inn, and whenever dignitaries were in town he was called upon to serve them. Here he poses outside the Lightfoot House with President and Mrs. Nixon. (Courtesy of The Colonial Williamsburg Foundation.)

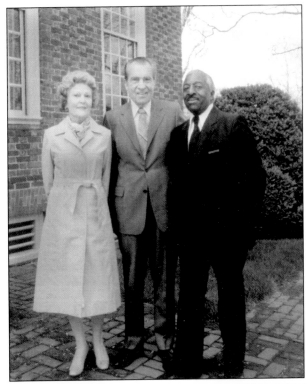

Rudolph Bares Jr. led an anti-litter campaign while he was vice president and director of corporate services for Colonial Williamsburg. As such he was responsible for the Colonial Williamsburg-owned hotels and restaurants. He was a well-known advocate of conservation and environmental protection, active in the Chamber of Commerce, and served on the Williamsburg School Board. (*Daily Press* photo.)

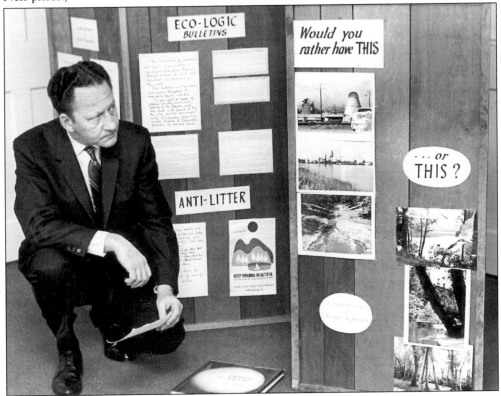

Jeanne B. Ethridge, who grew up in Williamsburg and was graduated from William and Mary, began teaching at Matthew Whaley School in 1931 and retired as the school's principal in 1973. (*Daily Press* photo by Mary Goetz.)

Raymond F. Freed, unpacking furniture for Lafayette High School, began teaching at Matthew Whaley in 1950. He moved in 1955 to James Blair High School where he taught history, social science, and government. When Lafayette High School opened in 1973 he taught there and, for a few years, was assistant principal. (*Daily Press* photo by Mary Goetz.)

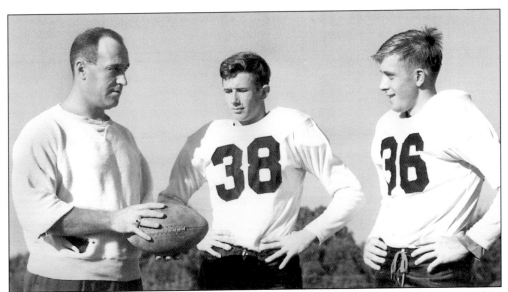

Before he coached the Matthew Whaley Governors, John Korczowski, left, was an outstanding fullback for the William and Mary Indians. Here he passes along some pointers to the co-captains of the 1948 team, Bob Richardson (center) and Perry Deal (right). Korczowski remained in Williamsburg as an investment broker and was president of the Kiwanis Club.

Jack Carter, who was graduated from Matthew Whaley High School in 1953, was a standout on the baseball diamond for the Governors. At various times he was pitcher, first baseman, and outfielder. He also played for James City in the Tri-County League, hence his "JC" cap. (Photo by Don Weymouth.)

Among the many ladies who were active in Garden Club activities were Crit Wasson (left) who won the Tri-Color Award in a flower show staged by the Williamsburg Council of Garden Clubs under the chairmanship of Jean Cogle (right). (*Daily Press* photo.)

Among the many supporters of the Williamsburg Hospital Auxiliary were Lovie Walker (left) and Jean Cutler, here admiring a silver tea service. The auxiliary's ice cream social has become a major part of the city's Fourth of July celebration. (*Daily Press* photo.)

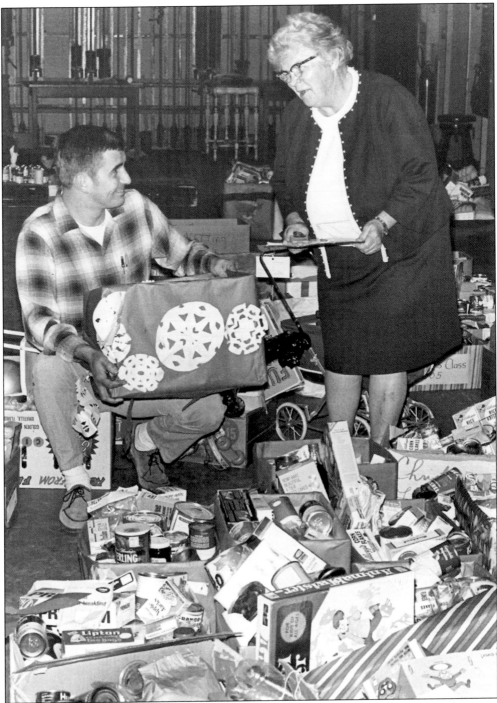

For many years in the 1960s and early 1970s, the distribution of food and toys to deserving families at Christmastime was a project undertaken by Martha Barksdale, here assisted by John Donaldson. Barksdale, who was among the first female graduates of William and Mary, taught women's physical education at the college for 45 years. Donaldson, who taught at the law school for 35 years, served on the James City County Board of Supervisors. (*Daily Press* photo.)

Donald Bentley (right) brought radio to Williamsburg as the general manager of WBCI. He was also active in the Kiwanis Club and was instrumental in the establishment of a park behind James Blair School. With him is Paul Hudson, the city's director of recreation. (*Daily Press* photo.)

Serving as judges for an exhibition at the Twentieth Century Gallery are Lawrence Kocher (left), a noted architectural historian, and Peter A.G. Brown (right), who in subsequent years was a vice president of Colonial Williamsburg.

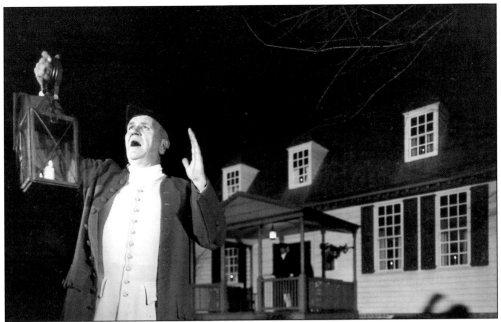

After serving in the Navy during World War II, Ray Townsend graduated from William and Mary and joined Colonial Williamsburg as an interpreter of colonial crafts. He was a master bootmaker, lawn bowling instructor, and served as town crier for such events as the Grand Illumination at Christmastime. (Courtesy of The Colonial Williamsburg Foundation.)

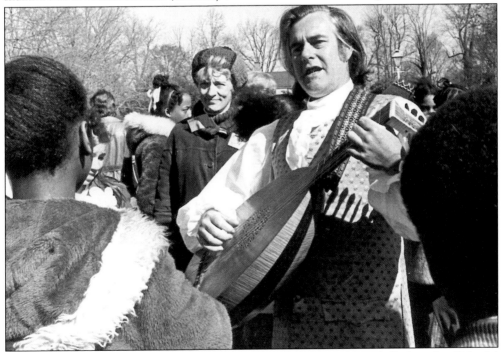

Taylor Vrooman, after graduating from William and Mary, was a balladeer for Colonial Williamsburg, regularly appearing in the taverns and at various public events. Vrooman's repertoire of 18th-century songs—especially bawdy ones—was extensive. (*Daily Press* photo.)

Earl C. Hastings Jr. and his son, David, pursued an interest in the Civil War that resulted, years later, in the publication of their book, *A Pitiless Rain: The Battle of Williamsburg, 1862*. Here they examine one of the several Confederate earthworks east of Williamsburg. (*Daily Press* photo.)

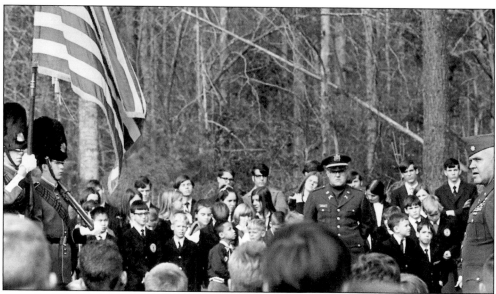

After he returned from the Korean War to complete his studies at William and Mary, Waldemar M. Riley, right, recruited an Army Reserve unit, C Battery, 3rd Battalion, 36th Artillery. Here Riley, who retired with the rank of colonel, delivers a talk on patriotism to students at Walsingham Academy. The sergeant is John Watkins, who for a time was executive secretary of James City County. The color bearers are members of the Queens Guard at William and Mary. (*Daily Press* photo.)

Billy Goodwin, the son of the Rev. W.A.R. Goodwin and who was known in the family as "Squinch," withdrew from the University of Virginia to become a P-40 pursuit plane pilot in the Army Air Corps. He participated in the North African campaign and was killed on a dive-bombing mission at Pandazzo, Sicily. Twenty-four servicemen from the Williamsburg area died during World War II.

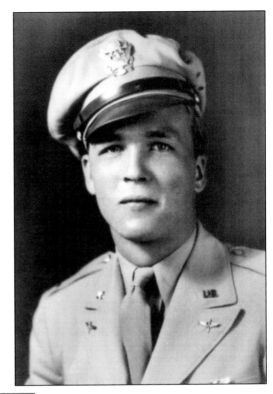

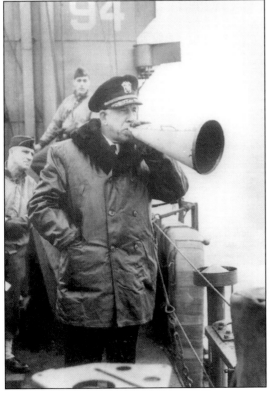

Williamsburg's senior war hero was Rear Adm. John Lesslie Hall Jr., who developed and perfected amphibious landing operations in North Africa, Sicily, and Italy. He commanded a task force of 691 ships that landed elements of the V Corps on Omaha Beach. (Courtesy of Department of Defense.)

Passing out daisies on election day is Charles "Sonny" Forbes, who served on the City Council from 1970 until 1974. (*Daily Press* photo.)

Shirley Low greets voters at the polls; she served on the city council from 1974 to 1978. She is reaching out to Delegate George Grayson, who is shaking hands with Robert C. Walker, left. (*Daily Press* photo.)

An effective member of the City Council from 1984 until 1992 was Stephen Harris, an attorney seen here in the courtroom. (*Daily Press* photo by Thom Slater.)

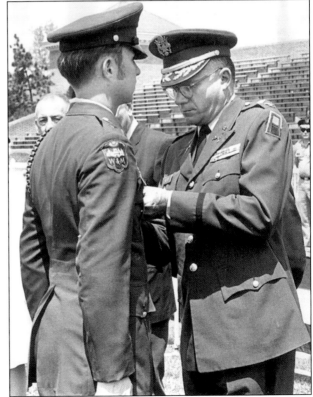

Army Col. John Hodges, who grew up in Williamsburg and fought in Europe during World War II, was elected to the city council in 1980 and served as mayor from 1986 until 1992. His last active duty assignment before retiring was as professor of military science at William and Mary. Here he awards a medal to ROTC Cadet Michael Wakefield. (*Daily Press* photo.)

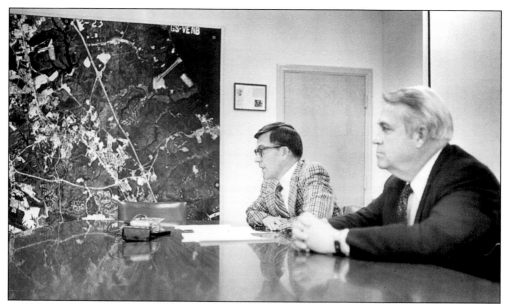

Pondering ways to control development are Jack Edwards (left), a member of the James City County Board of Supervisors for more than 25 years, and Robert Walker, who was mayor of Williamsburg from 1980 to 1986. Edwards was board chairman in 1981 when this picture was taken. In the 1986 municipal election Walker and Mary Lee Darling tied with 636 votes each. Darling was declared the winner when her name was drawn from a tricorn hat. (*Daily Press* photo by Joe Fudge.)

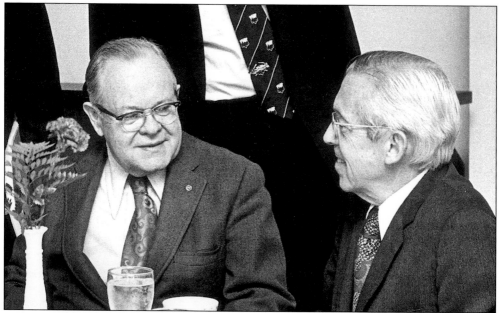

Charles F. Marsh (left), who taught business administration and later was dean of the faculty at William and Mary, served on the City Council from 1948 until 1952. He later left Williamsburg to become president of Wofford College. With him is J. Wilfred Lambert, who in his long tenure at the college held several administrative positions including registrar and dean of students. (*Daily Press* photo.)

Tom McCormick sets out the playbill on the sidewalk in front of the Williamsburg Theater in 1950, an era when movie house ushers wore uniforms. McCormick later was manager of the theater and ran a taxi and limousine business. (Courtesy of The Colonial Williamsburg Foundation.)

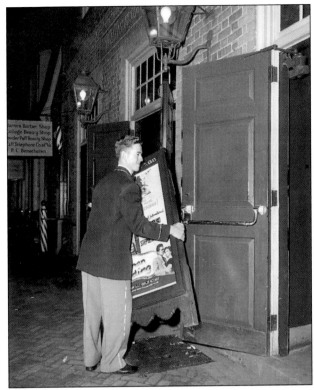

Williamsburg housewives used to wait for Henry M. "Buck" Hazelwood to unload the corn and other fresh vegetables that he brought to town from his farm in James City County. When the farmers' market at Lafayette and North Henry streets closed, he got special permission to put up his stand at the Williamsburg Shopping Center. (*Daily Press* photo.)

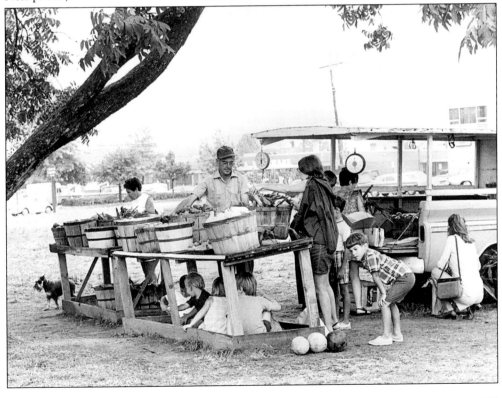

Marguerite Osborne, whose father, J.A. Osborne, restored publication of *The Virginia Gazette* in 1930, was associated with the weekly newspaper from 1938 until the family sold it in 1960. Family members assisted Marguerite while she served as editor of the paper. Her brother Alex was business and advertising manager and two sisters, Mildred "Midge" Adolph and Marion Osborne, wrote social news and editorials.

Fred L. Frechette (second from the right) established the Williamsburg Bureau of the Richmond *Times-Dispatch* in April 1952. For five years he held what he considered to be the oldest news beat in the country. Here he is on hand as President Eisenhower enters the House of Burgesses in 1952, followed by Winthrop Rockefeller. The newsmen flanking Frechette are unidentified.

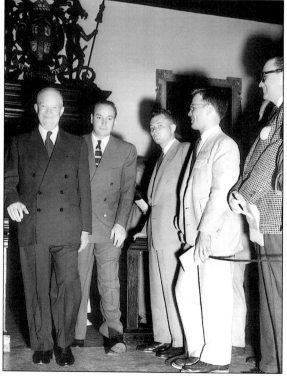

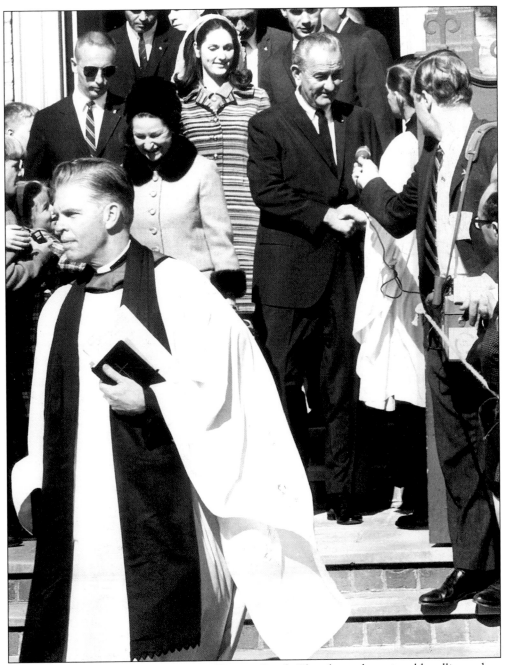

The Rev. Cotesworth P. Lewis, rector of Bruton Parish Church, made national headlines when he, during a sermon November 12, 1967, with President and Mrs. Johnson in the congregation, asked for a "logical, straight-forward explanation" of U.S. involvement in the war in Vietnam. Lewis said Americans were "appalled" and "mystified." Johnson declined to comment to newsmen as he left the church, followed by his daughter, Lynda Bird, then engaged to Marine Capt. Chuck Robb, who is in the background. Lady Bird Johnson complimented the choir. Officials of Colonial Williamsburg said the sermon was "in exquisite bad taste." (*Daily Press* photo.)

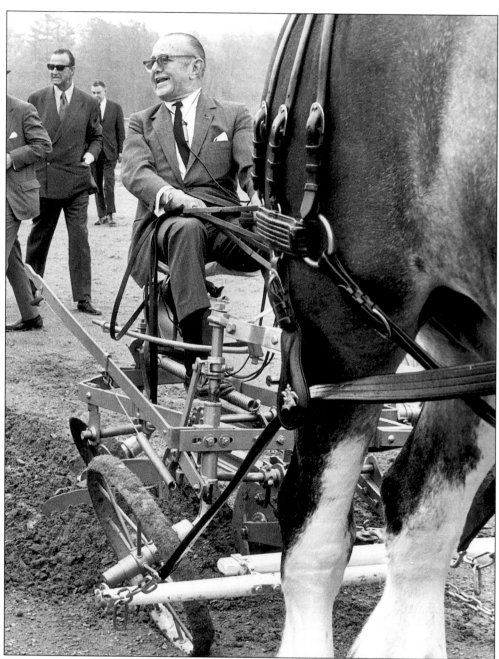

August A. Busch Jr., president and board chairman of Anheuser-Busch Inc., sits on a ceremonial golden plow and holds the reigns of eight Clydesdale horses for the groundbreaking April 29, 1970, of the brewer's $40 million Williamsburg plant. Among the dignitaries in attendance was former St. Louis Cardinal great Stan Musial. The development of Busch Gardens/The Old Country and the Kingsmill residential community immediately followed, adding new dimensions and character to Williamsburg. (*Daily Press* photo by Mary Goetz.)